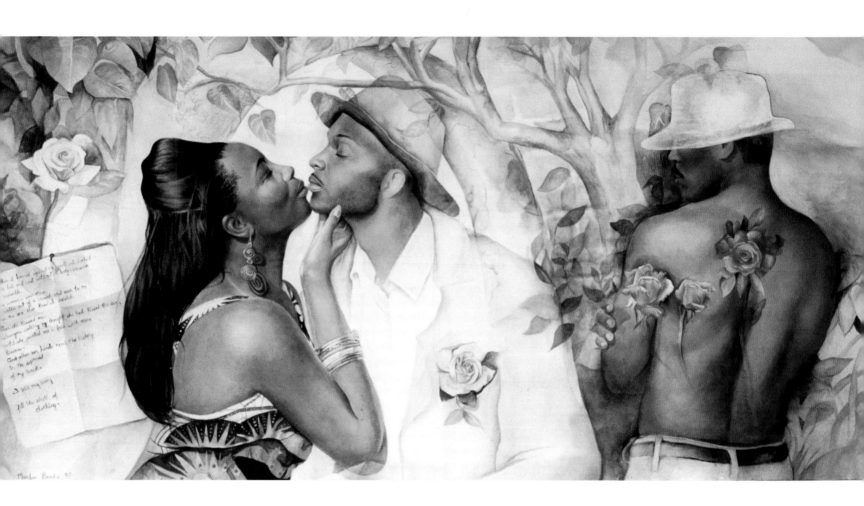

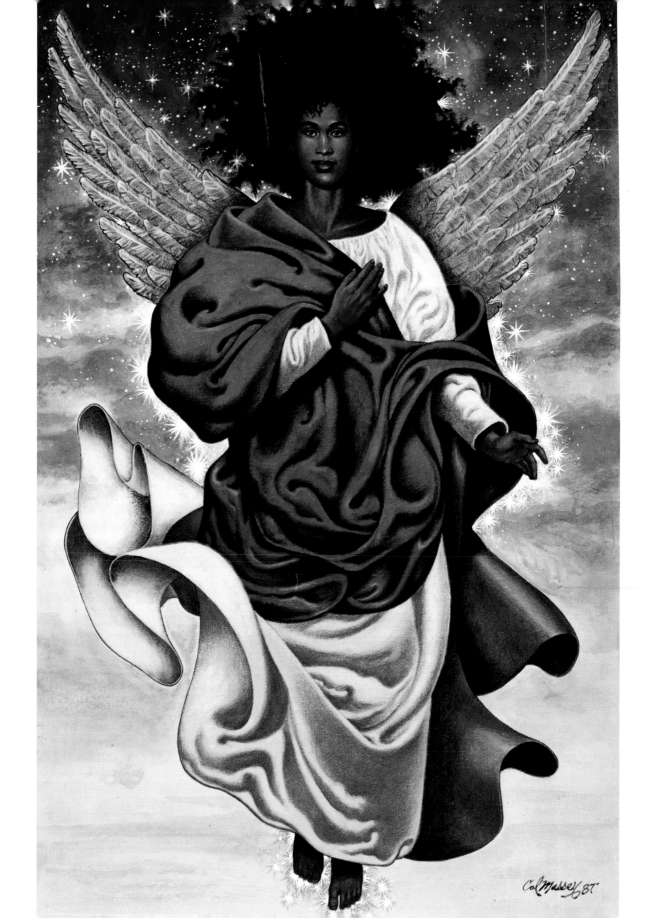

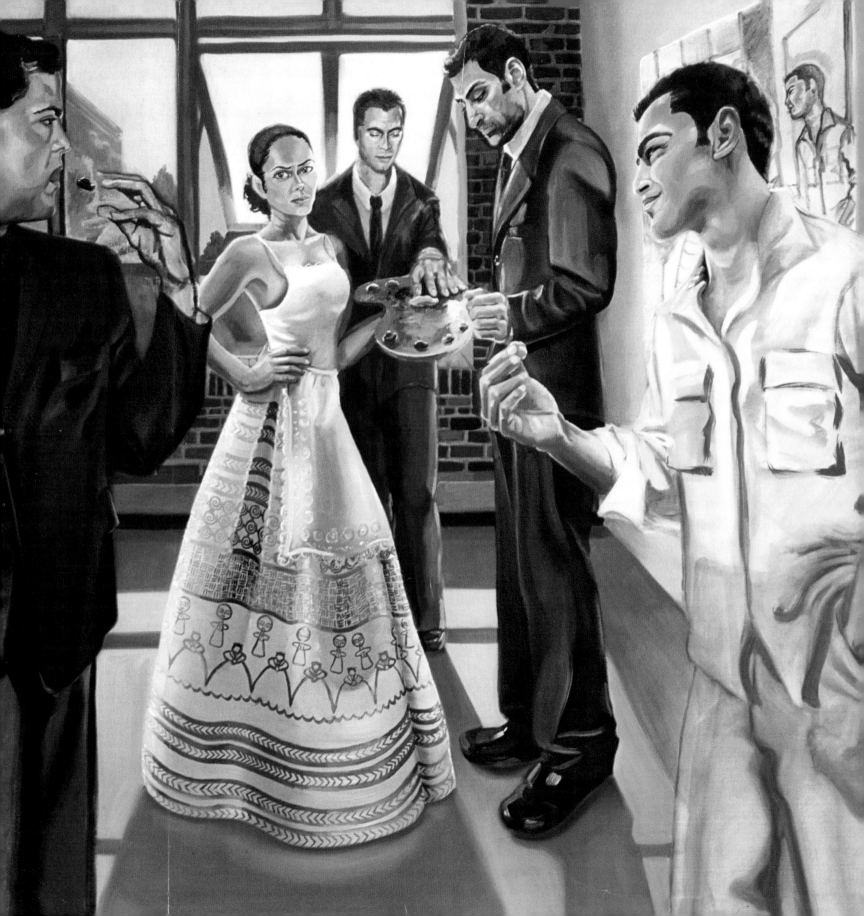

Black Romantic

Black Romantic

The Figurative Impulse in Contemporary African-American Art

THE STUDIO MUSEUM IN HARLEM

This publication was prepared on the occasion of the exhibition

Black Romantic

The Studio Museum in Harlem, New York
April 25 – June 23, 2002

The Studio Museum gratefully acknowledges its many supporters. Operation
of The Studio Museum in Harlem's facility is supported in part by public
funds provided by the New York City Department of Cultural Affairs and the
New York State Council on the Arts and by corporations, foundations, and
individuals.

Library of Congress Cataloging-in-Publication Data
Black Romantic/Thelma Golden with Valerie Cassel, Lowery Stokes Sims...
[et al.].
ISBN 0942949-23-4

The Studio Museum in Harlem
144 West 125th Street
New York, NY 10027
www.studiomuseuminharlem.org

Table of Contents

9

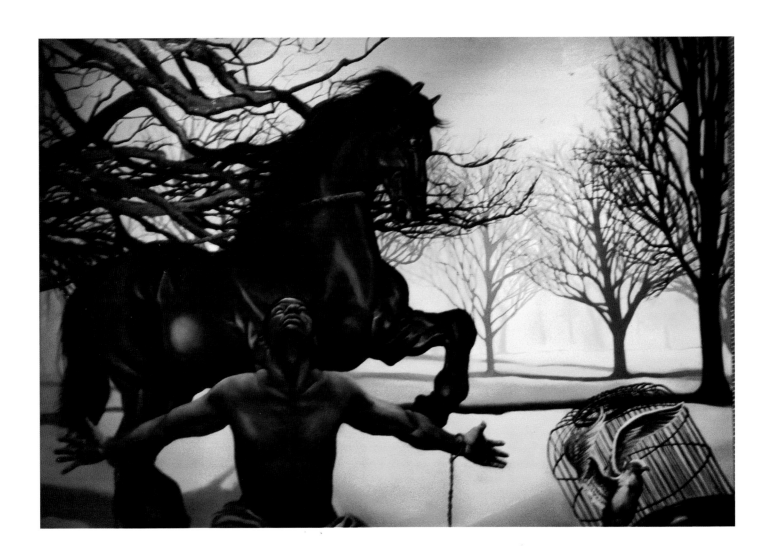

Director's Foreword

The Studio Museum in Harlem's Spring 2001 exhibition *Freestyle* challenged habitual notions of black identity by presenting the perspectives of a generation of artists of African descent formed by the consumption of global media and its mediation of images. The SMH's Spring 2002 exhibition, *Black Romantic*, presents perspectives that might be characterized as more forthrightly nationalistic and parochial, particular to the United States. In *Freestyle* issues of the global black experience—e.g. identity, trans-nationalism, cosmetology, engagement of electronic media—were shaped by conceptual and theoretical approaches. In *Black Romantic* elements of desire, dreams, determination, and romance particular to the black experience present a viewpoint that is oppositional to modernist conceptualizations of blackness flavored by exogenous exoticism, stereotype, caricature, and even abstractionist manipulation.

The question will be posed: which vision of blackness is the "authentic" one? As will become evident through reading the contributions in this catalogue by Thelma Golden, Valerie Cassel, Kelefa Sanneh, Franklin Sirmans, LeRonn Brooks, Regina L. Woods, Malik Gaines, and Christine Y. Kim, there is no clear-cut divide along the lines of generation, age, or politics with regard to the creators and audience of both artistic genres. In a sense they can be said to represent the dual aspects of the African-American defined in 1903 by W.E.B. Du Bois as "warring ideals" in a single entity. It might further be suggested that to position them as diametrically opposite to one another is to amputate the full expression of the black experience. Indeed the notion of blackness would be seriously blunted if the capacity for desire, dreaming, and conformity were to be isolated from a talent for irony, conceptual experimentation, and transgression.

Whatever the point of view of the individual visitor to *Black Romantic*, we can thank Thelma Golden, Deputy Director for Exhibitions and Programs, and her curatorial team of Christine Y. Kim, Assistant Curator, Rashida Bumbray, Curatorial Assistant, and our curatorial interns Ali Evans, Hannah Weinberg, and Michelle Wilkinson for a provocative presentation of a timely topic. Through the programming conceived by the Education and Public Programs Department under the leadership of Sandra Jackson, we affirm the Studio Museum's commitment to support a range of tendencies among black artists as well as to facilitate discussions of the issues explored by them in their work.

Last but not least, I would like to thank the participating artists, whose vision and creativity are the bedrock of this exhibition; their galleries and dealers, who have facilitated the loans; and the lenders to the exhibition: Ernesto Butcher, Pamela and Kevin Carter, Carol Cody, Martha Comer, Bruce Gordon and Tawana Tibbs, Evelyn Higginbotham, James Howell, Reginald J. Lewis, Dr. Catherine Lowe, John and Sharon Matthews, John McClain, Roslyn McClendon, Laura and Richard Parsons, Carl and Mary Roberts, William and Gail Robinson, Danny Simmons, Mark Watts, Dr. Thelma Wiley, Darrell and Paula Williams, Dr. George A. Williams, Jr., and Malika Young.

Lowery Stokes Sims
Director

GERALD GRIFFIN
The Yearning, 2000

11

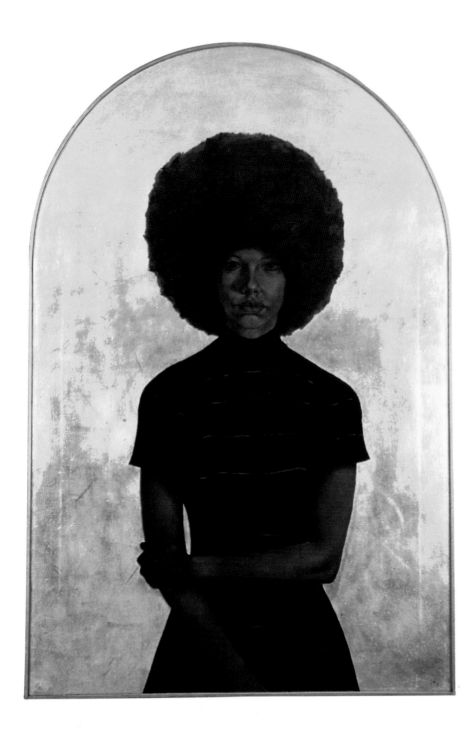

12

To Be Real

THELMA GOLDEN

A few years ago, after purchasing their first home, a good friend and her new husband bought their first work of art. This was a very big deal for them. It was their first serious purchase, meant to replace leftover college posters and prints bought on vacations; it symbolized the beginning of their art collection. After they bought the painting and hung it in its place of honor in their living room, they invited me over. When they mentioned the name of the artist on the telephone and I didn't recognize it, intuitively, I knew the road we were heading down.

Ostensibly, my friend's husband wanted my opinion simply to confirm that he hadn't spent too much on the painting. He thought of me as an art professional; as he was a lawyer who would and could offer an opinion on a legal matter, he wanted a professional opinion. But his wife, I could tell from the urgency of the call and the urgency of her desire to have me over, wanted me to confirm her sense of her "good taste" in "art." When I arrived at their home, I was immediately ushered into the living room to see the painting and after a long, uncomfortable silence, I said, "It is very nice." In what was then perhaps ten years as a curator, I realized I had never described a work of art as "nice." My euphemism of choice for work I did not like was "interesting," because truthfully, even if I did not like a work of art, I was at least interested in why I did not like it.

The painting was large and featured an image of a black woman in a contemplative pose. She was indoors, near a window, and the light streaming through the window cast a golden glow on her face and the room. She was fully clothed and dignified in her appearance and comportment. There was nothing wrong with my friend's painting. It was well painted and meticulously framed. It was nice—that is, it was completely undemanding. It was, perhaps, even beautiful in a very unchallenging way. It didn't seem to warrant repeated viewing, as it seemed to reveal itself upon first viewing. It went against everything I thought art should be. And *that* was interesting—as I realized over time and repeated visits to their home.

* * *

For years I had a recurring professional experience that became conflated in my mind with the former personal experience. Often, when I traveled outside of New York City, I encountered a world of ideas that I had no real frame of reference to understand. A typical experience would involve me giving a lecture at a museum or a university. After my talk, which might revolve around some aspect of contemporary African-American art and the exhibitions I had organized, I would be asked a variation on the same question. It is the kind of question that the artist Glenn Ligon and I refer to as "the kufi question," as it is often dressed in a rhetoric of intense nationalism. The question involves the asker wanting to know where the "real" "black art" that spoke to the "community" fit in my cosmology of aesthetic production. The questioner would cite artists by name, and I'd know instinctively that they were referring to artists like the one whose painting my friends had purchased or artists I had seen in self-proclaimed galleries of "black art." With these and other troubling (to me) conceptions of "race" and "authenticity" sprinkled in, the question

BARKLEY HENDRICKS
Lawdy Mama, 1979
Collection of The Studio Museum
in Harlem

usually was bracketed by notions of "relevance" and the role of art; most often, it positioned "aesthetic values" in racial terms. The term "black art" was used as an honorific. Never was the question posed with any of these terms in quotation marks, as I have added.

I could, of course, frame these questions and comments in relation to the culture wars happening in both the mainstream (August Wilson vs. Robert Brustein; Chris Ofili vs. Rudolph Giuliani; Spike Lee vs. Quentin Tarantino) and, more interestingly to me, in African-American communities (Toni Morrison vs. Terry McMillan; Wynton Marsalis vs. the entire hip hop community; *The Piano Lesson* vs. plays in the genre of "Mama, I Want My Man Back"). I don't think I have ever answered the question adequately, because of my own trepidation at entering any further into this fractious domain. Yet, these experiences, personal and professional, led me to wonder if an exhibition could be conceived out of a question. My own approach to curatorial practice was one that assumed an exhibition as a resolution to an intellectual or aesthetic inquiry. That notwithstanding, I valued the space of the exhibition as a perfect site for encounters that could not feasibly, because of ideological gulfs, happen in the world. There was a nation of black artists making work seriously and successfully—a nation of black artists toward whom I felt, again personally and professionally, both extremely distant and uncomfortably close, and I desperately needed to come to terms…

I needed to come to terms, not only so I could respond more intelligently to the questions of art-eager friends, but also because now, in my position at The Studio Museum in Harlem, these arguments became more than simply academic. From my former position in the mainstream—and I use the term advisedly—it was easy to leave the questions posed to me woefully unanswered. My own curatorial practice

had gone unnamed, but clear in its embrace, intellectual parameters, and aesthetic exclusions. I worked with artists who created in a postmodern discourse, even as they might question it. They formed the vanguard of post-conceptual interrogations of race, gender, and identity. They were "post" many things. But now at SMH, a museum founded as a corrective to the exclusion of African-American artists from the canon of American art, wasn't it perhaps time to explore the (mutual) exclusions perpetuated within the black cultural community?

* * *

With apologies to my mother—who always insists that I do not shape things in the negative—I have to explain the conception of this exhibition in terms of what it isn't. This exhibition isn't a critique. It isn't comprehensive or exhaustive. It isn't a corrective or a compensation. It's an encounter. It is a curatorial inquiry. The exhibition probably won't resolve the gulfs I have experienced and, it is possible, it might uncover a few others. *Black Romantic* attempts to bring the figurative artists of the world of black art galleries and art fairs into the museum. It should be said that the exhibition isn't an exercise of validation, as was the case with the entry of black self-taught, outsider artists into museums and the art world; the *Black Romantic* world, in a tradition typical of the African-American community's mode of self determination, has its own systems of validation in which The Studio Museum, quite honestly, does not figure at all. *Black Romantic* also attempts to understand "the popular" and how artists with openly populist ambitions understand the black audience in a way that perhaps I, and even this institution, at certain points in its history, never have.

The style of images in *Black Romantic* seem to be ubiquitous in African-American culture, exposing the weakness of common cultural dichotomies such as high/low; margin/ center; positive/negative; art/illustration. My over-

arching goal was to try to understand the figurative impulse in contemporary African-American art. I was not only interested in why, at this moment, this group of artists chose to work within the domain of figurative realism, I wanted to understand the undercurrent of aesthetic conservatism and political rhetoric that circled around this world. I also wanted to understand why African-American audiences had such a profound desire, even love, for this work.

The art for *Black Romantic* was selected through a research process and an open call, a format chosen both because of its alleged democracy and as a salve against my own curatorial insecurity. While I had been encountering the genre of work the exhibition presents for some time, I did not know where to go to find it. Or rather, the places I knew to go seemed, as my own curatorial identity became more formed, unapproachable. My research began online. Using the most generic of the search engines available, I typed in "African-American art" or, as I found even better, "black art." What came back astounded me. The Studio Museum in Harlem, for example, was nowhere to be found in the search engine's results. What I did find were hundreds, thousands of sites devoted to the presentation and sale of "black art." And while there was the odd large edition Bearden print among them, most of the art and the artists were unfamiliar to me. It was through the relative anonymity of these sites that I began to open call.

Via email and traditional mail, a simple flyer was sent around to dozens of galleries, site masters, and community centers around the country. Borrowing some of the language gleaned from the "black art" sites it read: "Attention, Artists. Seeking figurative, imagery, romanticism, realism and/or social realism by contemporary African-American artists…." It went on to ask for images to be sent for a "figurative exhibition." I had no idea what this would produce. Over the course of

several months, I received hundreds of entries from all over the country. They ranged from Sunday painters to corporate graphic illustrators, art students to art professors. I received instamatic photographs and professionally produced presentation packages. I received calls from art dealers, curators, agents, teachers, wives, and neighbors all on behalf of artists they felt should be included in the exhibition. The range was astounding. From this wide group, I began to gather an understanding of the genre. My research also quickly identified several artists whom I contacted directly, and formally asked to consider their work. The results of this process ultimately led to the thirty artists whose work is presented in this exhibition.

While there are black artists working in all genres, *Black Romantic* focuses on figuration because it is the aesthetic and intellectual trope that so many of the issues that led to this project engage. Figuration, of course, plays a central, critical role in the narrative of African-American art. This history, and the Studio Museum's seminal role in helping to write this history, must be kept in mind when considering the significance of the exhibition. Concurrently, the encounters

THE **Studio Museum IN Harlem**

144 West 125th Street, New York, NY 10027 • 212 864-4500 • Fax 212 864-4800

------ **ATTENTION, ARTISTS!** ------

The Studio Museum in Harlem
Open Call for Submissions

We are currently seeking black figurative imagery, romanticism, realism and/or social realism in original painting, drawing, sculpture or mixed media by contemporary African-American artists

Submissions must include the following materials:

1. Slides or color photographs of the work (Do not exceed 20 images and do not include the original work)
2. Artist bio or resume including training and past exhibitions
3. Artist statement explaining the work, descriptive materials or reviews
4. A self-addressed, stamped return envelope

Please send materials to the following address by October 1, 2001:

The Studio Museum in Harlem
Curatorial Dept/Figurative Exhibition
144 West 125th Street, New York, NY 10027

SMHcuratorial@aol.com, www.studiomuseum.com

with conceptual figuration so dominant in recent contemporary art also provide a context. Through two distinct paths—African-American art history and contemporary art practice—I created the space to conceptualize this project. Joshua Johnson and John Currin. Eldzier Cortor and Lisa Yuskavage. Ernie Barnes and Norman Rockwell. Barkley Hendricks and Richard Phillips. Charles White and Kerry James Marshall. Elizabeth Catlett and Kara Walker. Kehinde Wiley and Kurt Kauper…

I do not intend, and have never intended, *Black Romantic* to be a critique. An exhibition as critique, or even as conceptual exercise, would be too easy intellectually and would allow me, and by extension the museum, to remain rooted in an uninteresting, unproductive oppositionality. Before committing to this project, my relationship to this world was informed by my perceptions. I was often physically unsettled by what I perceived to be the overwrought sentiment, strident essentialism, and problematic authenticity that is the lingua franca of this world. I shuddered at the crass commercialism, the rampant reproduction, and the bombastic self-promotion I often encountered. I seemed caught in a clash of values and I could not read past any of that. Mostly, I was suspicious of the notion of the "real" or the authentic that many of the artists strive to present. The "real" seemed based on a mixture of revisionist history and willful fantasy, weirdly combined with reportage. The absence of irony is profound. Directly translating or visualizing the language of black empowerment, the art operates as an anecdote to perceptions of a conspiracy to promote "negative" images in the mainstream press, black popular culture, and even in the work of other African-American artists.

The curatorial challenge of this project was the suspension of judgment—not curatorial or aesthetic judgment—but the suspension of value judgment. And while I have not changed my opinions about what might or might not constitute valid art practice, these opinions have widened to acknowledge this world as a world valid within itself. It is from the acceptance of this validity and a profound intellectual openness that this exhibition emanates. The real conversation will begin when the work is on the walls of this museum and these artists have the chance, through their work, to speak to audiences who already know them, as well as to audiences who have never encountered, or perhaps have avoided them in the past.

The thirty artists in *Black Romantic* represent a cross-section of this large and vital world. They are from all over the United States and range from their mid-20s to their mid-70s. Some are self-taught, most are trained. They are all serious artists. Their resumes speak to a world different from mine, populated with juried exhibitions, culturally specific and regional art spaces, corporate commissions, and numerous awards and prizes. Their resumes also evidence an impressive level of achievement. In the statements that came with some of the original submissions, they describe themselves as artists and also as educators, anthropologists, archivists, actors, and activists. The works selected represent not only the aesthetic of their authors, but also some of the archetypes of the genre. There are strong black men and wise elders. There are beatific children and passionate couples. There are revealing portraits and allegorical narratives. They embrace notions of uplift and beauty. But there are also images that seem complicit in some of the roles they simultaneously critique. These artists, as image-makers, are involved in a crucial project. Because no categories can be essential, there are several artists in *Black Romantic* whose work straddles multiple cultural, aesthetic, regional, and ideological communities. They, more than I, have defined their practice and the exhibition provides an opportunity for all of us to engage and cross cultural worlds.

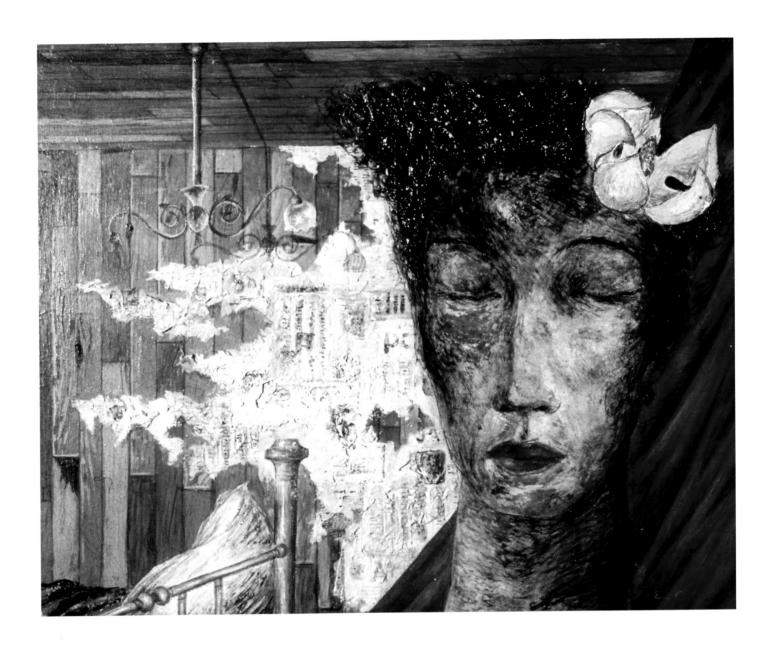

Black Romanticism:
The Will Toward Imagistic Sovereignty

LOWERY STOKES SIMS

For African-American artists, painter Robert Colescott once noted, rarely are "images…assumed to be incidental to the meaning of the work."[1] The work of the artists included in the exhibition *Black Romantic* would demonstrate this truism. It is specific in its modalities, deliberately eschewing strategies and stances that have been brought to the black image over the last three decades. There is no irony, nor satire; it offers no transgressive engagement of caricature or stereotype, and demonstrates a scant tolerance for abstractionist manipulation. It would be easy to dismiss this imagery as "retardataire," anti-progressive, nostalgic. In the context of modernism, according to the tenets of vanguardism that have propelled artistic development over the last century and a half, such imagery would be associated with a conservatism that has been the hallmark of specific political tendencies associated with anti-progressive trends. To dismiss this imagery thusly, however, would be to overlook its underlying intention that many in the black community believe to be inextricably tied to their survival: the presentation of what the curators of this exhibition describe as representational, expressive, and iconic figures that reflect urban or rural, domestic or exterior experiences as well as utopian and allegorical aspirations.

Although aspects of black romanticism can be found in the work of African-American artists as diverse as Romare Bearden (who created adroit collages from found and crafted snippets) and Robert Colescott (who paints in a sturdy, brushy style), the conceptual framework of this imagery and the theoretical direction of its practitioners in this exhibition can be seen as co-tangent with photography. As the artists in

Black Romantic strive for verisimilitude, black photographers, notes scholar Robin D.G. Kelley, used the camera as a "mighty weapon" when "the deliberate distortion of black images in popular cultures was…common."[2] Their contemporaries began at this point to offer proactive images in painting and sculpture after a long prelude during the nineteenth century when black artists—such as Robert Duncanson, Edmonia Lewis, Annie Walker, Grafton Tyler Brown, Edward Bannister, and Henry Tanner made their mark (and their point) within the American mainstream in landscape painting and representations of myth, history, and genre based on European and Euro-American models and subjects. These artists, however, did not for the most part engage black figures.[3] The exceptions include Edmonia Lewis's sculptures *Forever Free* (1867), and *Old Indian Arrow Maker and His Daughter* (1872), in which she celebrates her African and Native ancestries cast in classical conventions, and Henry Ossawa Tanner's *The Banjo Lesson*, showing an elderly black man teaching a youngster to play the instrument, whose potent dignity and sentimentality became an alternative to crude stereotypical images published on sheet music for so-called "coon songs."

By the beginning of the last century, artists such as William Edouard Scott began to specialize in portraiture and depictions of the black figure. Scott adapted a loose, gestural style in his depictions of survivors of slavery and the people of Haiti, where he visited in 1931 on a Rosenwald Foundation grant. Scott's career overlapped with the development of modernism and the art world's engagement of Africa during the first decade of the last century. By the second and third

19

ELDZIER CORTOR
The Room, 1949
Collection of The Studio Museum
in Harlem

decades black artists multiplied as newly founded art departments discharged their first graduates. In the context of the Harlem Renaissance with its focus on the celebration of black culture, images of black people proliferated from the modernist adaptations of Aaron Douglas and his contemporary Edna Manley in Jamaica, to the more academic approaches of James Porter and Lois Mailou Jones. Artists such as Elizabeth Catlett, Charles White, and John Wilson combined both tendencies to build a repertoire of heroic and dignified images of blacks. Archibald Motley and Laura Wheeler Waring examined the rich variety of hues and features of black people and manifestations of their various economic conditions and lifestyles. Eldzier Cortor reveled in the black female creating sleek, attenuated fantasies of femininity—perhaps the first truly black romantic paintings—and Norman Lewis created adept Cubist interpretations married with expressionistic techniques that would characterize the work of Charles Alston, Hale Woodruff, and Jacob Lawrence during the 1940s and 1950s.

The most immediate precedent of this imagery is that which emanated out of black political movements in this country during the 1960s and 1970s. In the context of the struggle to meet the political and social aspirations of black Americans, the tenets of that imagery were positioned in opposition to mainstream art (which then was championing such manifestations as Pop Art and Minimalism), and in sync with a more separatist (as opposed to a more assimilationist) posture. That genre of black art philosophy asserted the purpose and content of art at a time in which such content was excised from official mainstream discourse. This is readily seen in *Black Art Notes*, edited by Tom Lloyd, in which several artists offered responses to the Whitney Museum of American Art's 1971 exhibition *Contemporary Black Artists in America*.[4] Writer Melvin Dixon laid out the terrain of that anti-mainstream stance: "Black Art, by definition," he wrote, "exists primarily for Black people."[5]

Furthermore, "It is an art which combines the social and political pulse of the Black community into an artistic reflection of that emotion, that spirit, that energy…Its aesthetics is [sic] deeply rooted in the day to day existence and/or activity of Black people." Dixon then asserts that the "aesthetic foundation" of black art "seeks to step beyond the white Western framework of American art which has enclosed and smothered any previous expression of Blackness."[6]

Dixon's prescriptions for an art that responded to the needs of the black community with a disregard of mainstream art theory was echoed in the aesthetic positions of other artistic groups such as AFRI-COBRA. Jeff Donaldson would firmly locate the criteria for black art in "our people" who would set "our standard for excellence": "We strive for images inspired by African people/experience and images which African people can relate to directly without formal art training and/or experience. Art for people and not for critics whose peopleness is questionable."[7] This sentiment resonates through *Black Romantic* suggesting an inadvertent but actual relegation of it with other anti-modernist tendencies in American art exemplified in the work of Norman Rockwell, or Andrew Wyeth. *Black Romantic's* pervasive feel of nostalgia and wishfulment, its hermetic, independent existence outside the critical mainstream, and its engagement of elements unique to a specific community within the view of modern and postmodern global realities also mirror qualities that mark Japanese modernist figuration between the world wars. All of these manifestations were created in the midst of modernism's evolution and permutation in the twentieth century, and were consequently dismissed by the critical and theoretical thought that buttressed that progression. Postmodernism, however, offered a context within which these manifestations could be reconsidered and re-evaluated. Indeed as *Black Romantic* is being presented at The Studio Museum in Harlem in spring

2002, Rockwell's work is being presented at the Guggenheim Museum, a bastion of modernity, Wyeth's work is the foil for a transgendered interpretation in the work of an artist presented at the Whitney Museum of American Art's 2002 *Biennial Exhibition*, and the Honolulu Academy of Art is presenting an exhibition of Japanese modernist figuration in its ground-breaking exhibition, *Taisho Chic: Japanese Modernity, Nostalgia, and Deco*. While we are used to relegating the visual ambitions and expressions of individuals outside the rarefied art world to the realm of kitsch, it took hip hop culture—with its unabashed exposure of the specificity of urban group expression—to give a specifically black aesthetic viability—if not quite legitimacy—within the larger American consumer society.

　　　　If the black public seeks a readily accessible imagery and basks in its affirmation of "traditional" values in a contemporary world where it is perceived that all contemporary art seeks to do is to challenge and offend,[8] the values represented in *Black Romantic* are pertinent and audacious manifestations of the Lacanian "mirror image." African Americans continue to search for their image in the looking glass of contemporary visual culture, finding there many versions of themselves that have been reflected back from the mainstream through multiple refractions, when what they desire is a version that is "real" and "affirmative." *Black Romantic* may therefore be said to represent the legacies of myriad individuals—such as artist Romare Bearden and writer Jean Toomer, musicians Archie Shepp and Cecil Taylor—who have taken this task in hand, who, in the words of Ntozake Shange, have "documented our lyricism," allowing black people to "surrender to the energy of ourselves—unselfconscious, lustful, fragile, trusting."[9] In her opinion, at this moment in time, "with the African continent shattered by war, famine and AIDS, with our folks dazed by the deconstruction of Reconstruction, sex and sensuality are elements of any progressive discussion."[10]

Therein lies the audacity of *Black Romantic* and inherently its ultimate impact. It presents aesthetic criteria that emanate from a particular African-American experience and according to which many in the African-American community feel they can find their way as fully realized entities on this planet.

1. Quoted in Ann Shengold, "Conversation with Robert Colescott," in *Robert Colescott: Another Judgment*, essay by Kenneth Baker (exhib. cat.; Charlotte, N.C. :Knight Gallery/ Spirit Square Arts Center, 1985), n.p.
2. Robin D.G. Kelley, Foreword, in Deborah Willis, *Reflections in Black: A History of Black Photographers 1840 to the Present* (New York and London: W.W. Norton & Company, 2000), ix.
3. Albert Boime, however, reminds us that there was no lack of fascination with the black image among "privileged white artists," and that as a phenomenon this imagery demonstrates "strategies of cultural practice in addressing societal conditions" and "how both the oppressors and the oppressed struggled for recognition, power and control over their lives." See Boime, *The Art of Exclusion: Representing Blacks in the Nineteenth Century* (Washington and London: Smithsonian Institution Press, 1990), xiv.
4. *Black Art Notes*, edited and with an intro. by Tom Lloyd. 1971, n.p.
5. Ibid, 1.
6. Ibid.
7. Quoted in Mary Campbell Schmidt, "Tradition and Conflict: Images of a Turbulent Decade, 1963-1973," in *Tradition and Conflict: Images of a Turbulent Decade, 1963-1973* (exhib. cat.; New York: The Studio Museum in Harlem, 1983), 58.
8. See Jack Hitt, "America's Problem with Modern Art," *The New York Times* (March 17, 2002), sec. 4, 3.
9. Ntozake Shange, "Fore-word" in Miriam DeCosta-Willis, Reginald Martin, Roseann P. Bell, eds., *Erotique Noire/Black Erotica* (New York and London: Anchor Books/ Doubleday, 1992), xx.
10. Ibid.

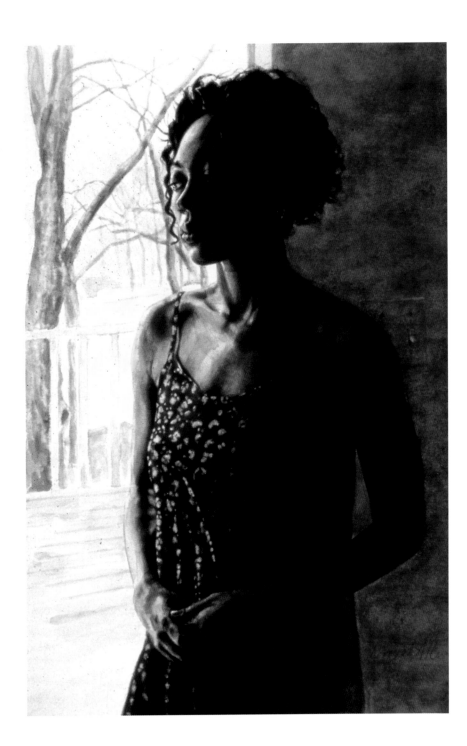

Who Will Speak for Us?
A Utopian Romance Novelette

VALERIE CASSEL

Romance and beauty are being re-examined in contemporary American culture. After the tumultuous decades of the 1980s and 1990s, when cultural politics evoked a paradigmatic shift of diverse voices from the margins into the center, contemporary society is now ready to accept that what seemed to be a cultural crisis was little more than anti-trust policies toward a cultural monopoly.

In a time when isolationism has returned not as a truncation of an increasingly industrial society, but a global market, most Americans find themselves nostalgic for the sublime of romantic expression. During the Romantic period (1785–1830), literary and visual artists sought to translate the landscape into a collective language of a people from all walks of life caught in the quagmire of change. The revolutions in France and civil war in Spain and, moreover, the chattel and indentured servitude of hundreds of thousands of people of European and African descent hung in the balance. Visual artists subscribing to romanticism wanted to render solstice for this collective of humanity. Their submergence into the sublime sought to transcend the tumultuous reality of the masses and provide them with a taste of divinity by humanizing the very landscapes that enveloped them. The need to speak for the collective in a manner that sought to translate their fears, anxieties, joy, and happiness was an attempt to make visible the ethos of a people of this particular time in history when war, famine, and migration lent little weight to utopian ideals.

During this period, landscape and portrait painters like Robert Duncanson (1817–1872), set their emotions upon canvas. Duncanson masterfully contributed to this movement, while he simultaneously sought to avoid the restrictions that circumscribed his life as a person of African descent. Although Duncanson's landscapes are pedantically European in their academic rendering, his painting, *Uncle Tom and Little Eva* (1853), inserts within this pedantic frame the visual utterance of a black body in the American landscape. Given that the anti-slavery movement was gaining momentum at that time, one could see Duncanson's painting as a stance of activism. While his visual and sentimental framing of the black body in the landscape would take a century and several decades to be analyzed within a canon of activism, it is clear that Duncanson's portrait of blackness would become a foundation for the cultural empowerment of future generations of African Americans.

By the early twentieth century, collectives of African-American artists would be assembled to create a literary and visual arm to the activism of black people in America. As a political conduit to empowering the masses of black people migrating out of the antebellum South and into the northern reaches of America, the visual arts sought to establish a visual language that would not only speak to this population, but also render it strong in esteem and rich in utopian dreams. Such visual artists of this renaissance period did not exemplify the sublime through pastoral landscapes for those people now living in urban centers, but instead translated their painful pasts and narratives of daily struggle into a visual poetry of beauty. Devoid and unapologetic of their political stance, these painters and sculptors infused their own aesthetic expressions with activism that sought to end lynching and segregation

LEROY ALLEN
Contemplation, 1998

in the Jim Crow South as well as race riots in the North. The black body would become an iconographical identifier of strength, beauty, and courage. The sentiment and classical ideals during this period of an identifiable black aesthetic, are infused with a pulsating vitality that serves to chronicle and visually fictionalize living histories.

It is upon this established vernacular that the Black Romantic emerges. Building upon the subsequent decades (in particular the 1950s through the 1970s), the black voice and political aim grows increasingly agile and articulate and, continuously builds and shapes a visual vernacular that is both desired and consumed. This form of romance, however, by its very nature serves to bridge the chasm of art history and the history of black people in this country. As a visual expression for African Americans, it continues to encapsulate a collective spirit of beauty and a desire to expand upon truncated familial histories.

From such origins, Black Romanticism should not be dismissed as fictionalized nostalgia. Neither can it be categorically noted as the remnants of black empowerment and the effects of federal funding in disenfranchised urban centers. Black Romanticism, contemporarily speaking, engages aspects of a vernacularism reservoir that many Americans so desperately seek. It is a consumable, visual language designed and embraced to be, by its very nature, a radical act.

For the whole of American society, the collective voice is still mired in the individual moment. The only overriding exception is those artists who, from the 1980s and into the present, raise issues regarding the pandemic of AIDS. Today in the wake of terrorism (both at home and abroad), Americans are universally seeking to unify their collective feelings and to find a common language that speaks of hope, not fear. At the crossroads of this desire are both a sense of self-determined histories and an unrestrained assertion of self-representation.

Although Black Romantic images appear too repetitive, too sentimental and nostalgic, to be ushered into the fine arts canon without respite, these images can neither be dismissed as "period pieces." The efforts of black artists working outside the primary markets of contemporary art can teach contemporary society a great deal about our needs for community, rather than our desires to build upon a trajectory of contemporary practice. Such needs for community and communal language move beyond the narrow refrain of specific histories and into a universal yearning. As such, it is paramount to shift notions of art practice outside of racial boundaries and binaries. Suffice it to say however, that binaries and boundaries do exist as do secondary art markets. Presenters of contemporary art should continue to reach without judgment or voyeuristic leanings, but with an eye to filling the vacuum that has become increasingly evident in today's society.

The continuous assertion of the collective souls of black folks in an era of increasing complexity, one which recognizes the three-dimensionality of the black body, is in and of itself, a radical act with magnificent reverberations. Black Romanticism is still about the insistence of presence. The visual language used to render the images found within this exhibition is a vernacular that is easily consumed, yet rich in an art historical and collective history (albeit sometimes fictionalized). And, while sometimes pedantic, these images create a pragmatic space in which the black body is not only visible, but also safe. It is a collective lesson that a nation now begins to re-learn as a shared language but not upon ethnicity or race, but nationhood.

24

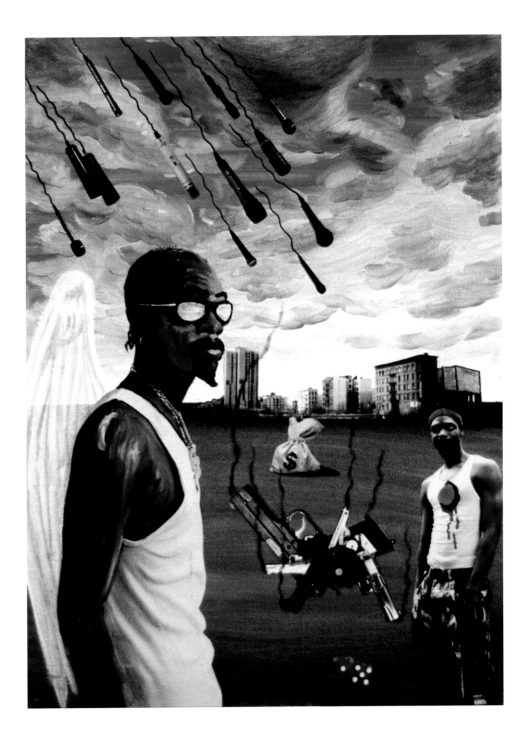

Types and Tales:
Reading *Black Romantic*

KELEFA SANNEH

Look at *Cain and Abel* by Keith J. Duncan. At first glance, you don't see "photo collage, marker, and oil on canvas." What you see is a collision of symbols: microphones, guns, dice, money, a victim, an angel. It's a pictograph, rendered in a kind of visual shorthand, and if the meaning isn't immediately obvious—are the microphones coming to save the day, or heading straight for the money, or just adding to the mess?—we still don't have much of a choice but to try and find one. It's not that questions of technique are irrelevant here. But it's hard to talk about Duncan's approach to collage or his style of brushwork when the symbols are so overbearing. It's a bit like being presented with a copy of the *New York Post*. The image and the font size are important, no doubt, but how can you resist reading the headline?

There's something unsettling about the angel, with his wifebeater, his reflective sunglasses, and his translucent wing. A thug angel: it sounds like a bad joke, and maybe it is. In any case, it's hard to know how seriously we should take it. Draw some wings on some guy's back, and you've made him an angel—is that all there is to it?

We're taught to be skeptical about the representative power of art, but an image like *Cain and Abel* seems to take for granted the notion that we know what we're looking at. It's one thing to treat the objects that way, but what about a person? Of course, "person" might not be the right word either. What we're looking at is a type: an archetype, perhaps, or a stereotype.

The works in *Black Romantic* are filled with archetypes and stereotypes, so ubiquitous that it's easy to ignore them, so obvious that it seems almost useless to point them out. And yet there they are: Duncan's thug angels, and Gerald Griffin's, too; Lawrence Finney's *City Girl* and Leslie Printis's city toddlers; dignified old folks and muscular basketball players and happy families. There are flights of fancy, too, such as Toni Taylor's *Gemini-Souls Akin* and Robert Jefferson's *Risen*.

These are types we're supposed to recognize at once, although many of them are familiar mainly as figures—we recognize them because we've seen them in other paintings. Their appeal is sentimental, and their familiarity is meant to inspire our affection. Toni Taylor, for example, is quick to remind us that her "characters" are "benevolent and wise." What's perplexing here isn't so much the fixed value ascribed to the figures, but the sense that the figures exist in their own fantastic world, with their own traits and attributes. The world she's talking about is filled with dragons and goddesses, but her general approach isn't so different from the other artists in *Black Romantic*. Virtually every character seems to live in a parallel world, a heterotopia ruled by idealism and sentiment.

* * *

This is hardly a new tradition in African-American art. And the tradition certainly isn't limited to art. If the works in *Black Romantic* constitute what might be called the commercial mainstream of contemporary black art, they are also descended from the storytelling tradition that has been central to African-American culture and literature. As Jonathan Knight puts it, "My paintings are allegorical in nature," which is to say, they are representational without necessarily being mimetic. They use types to tell stories.

KEITH J. DUNCAN
Cain and Abel, 2001

You could trace this tradition back to the slave songs about Gabriel and Ezekiel, or the street-corner fables of Shine and Stackolee. These characters are exaggerations—heroes and loudmouths, saints and crooks—and the stories of their lives are allegories, even if the characters seem to take on lives of their own that go beyond mere symbolism. Perhaps many of these stories aren't quite sentimental or idealistic enough to qualify as *Black Romantic*. But it's possible to discern a similar impulse, a narrative mode that eschews both characterization and abstraction.

In its most recent incarnation, this is the narrative mode of hip hop, which takes the tradition of black storytelling and turns back on itself, so that the storyteller becomes the protagonist in his own tall tale. When Ice Cube proclaims himself "the nigga you love to hate," or when the Notorious B.I.G. claims to have "sold more powder than Johnson & Johnson," they are, once again, using types—the outlaw, the pusher—to tell stories. These stories are, in some ways (although not all), "their own," which is to say that these are, in a sense, autobiographical allegories. We are supposed to recognize the types immediately, even if figuring out the stories is a much more complicated process.

But what are these types: archetypes or stereotypes? In hip hop, the language of aspiration gets jumbled up with the language of insult, and it's often hard to tell which is which. Are rappers creating new cultural ideals, or merely repeating libelous generalizations? Some people have tried to answer this question by trying to figure out whether any kind of rap music has socially redeeming value, and how much. Whether, that is, these types are being used for good or for ill. Others have tried to separate archetypes from stereotypes by figuring out how they're received, and by whom.

Lots of energy has been spent trying to answer questions such as these, and most of it, I'm afraid, has been wasted. With hip hop, as with *Black Romantic*, these aren't really the right questions to ask. Like lots of hip hop, the works in *Black Romantic* seem to reaffirm hoary old myths about African America. The paintings present a black nation that is spiritual, strong, loving, long-suffering, and dignified. These are idealistic stereotypes, but they are stereotypes nonetheless.

These paintings do not offer the voyeuristic thrill that makes hip hop so irresistible, the sense that we're getting a glimpse into a complicated life, full of contradictions and troubling details. And there are remarkably few jokes, here, as if any hint of levity would disturb the atmosphere of blissful pride. For the most part, the artists are hidden behind a scrim of idealism. Shamek Weddle created a *Self-Portrait at Age 24*, but it's hard to see anything except the idealized essence of African-American art: a black man with a paintbrush.

Still, there is much to see here, more than may be obvious at first. Dean Mitchell, for example, says he has won hundreds of awards, but he still regularly enters art competitions. "Shows keep me aware of what other artists are doing," he says. "They force me to constantly re-examine my own work. And the public has a short memory. You have to keep reminding them." Ah, yes. The public. If these images fascinate, perhaps it's because they seem to give us a glimpse of a world beyond the types: the world of the people who love the images, who collect them. "The public" is implicated in these images—these aren't so much portraits as they are aspirations, and when we look at them, we can't help but wonder, Whose aspirations are these, exactly?

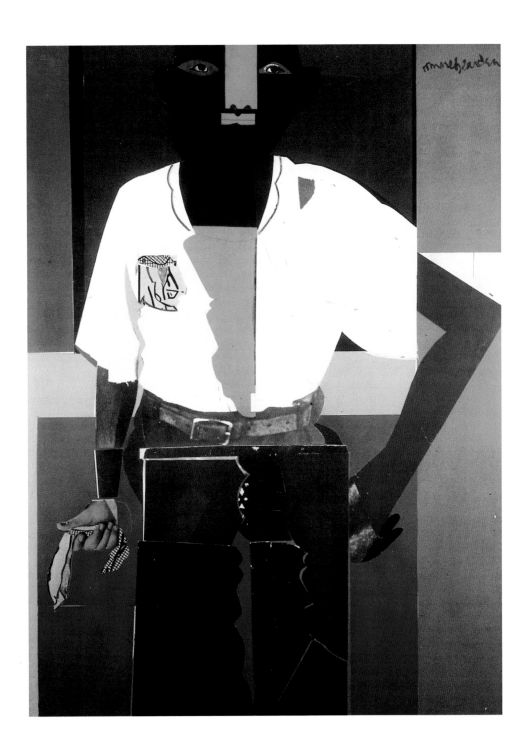

We've Got a Love Jones

The exhibition *Black Romantic* shares two separate yet inter-twined threads of art and cultural history. The first involves mapping the portraits of a racialized group of figurative realists. The second centers on the role of the individual artist within/without a collective. More than thirty years ago, Ralph Ellison asserted this duality in the development of black expression:

> He cannot avoid—nor should he wish to avoid—his group identity, but he flounders before the question of how his group's experience might be given statement through the categories of a nonverbal form of art which has been consciously exploring its own unique possibili-ties for many decades before he appeared on the scene; a self-assertive and irreverent art which abandoned long ago the task of mere representation to photography and the role of storytelling to the masters of the comic strip and the cinema.[1]

Though Ellison was speaking in reference to Romare Bearden, the competing ideas of the chasm he described and applied to the individual black artist in 1968 continues to be wide open.[2] The question of aesthetic choice is central to the work of all artists. Only five years before Ellison's essay, Bearden made the pivotal transition from abstraction to the figurative collages that made him famous. That moment of transition and chance helped change the map of western art history, though it was initially greeted by skepticism within the black community. "To many of my own people, I learn, my work was very disgust-ing and morbid," Bearden said. In fact, that wounded site of cultural memory has grown deeper, beyond the role of the individual to that of a cultural body (often, rightly) obsessed by its representational artistic image.

While Bearden came to prominence at a time with well defined political crises lying outside the complex ques-tions of formal artistic choice and the faddish, often incompre-hensible, desires of the contemporary art market, today's artists face many similar questions. In the wake of postmodernist debate, new technology and virtual reality, a range of artistic options and exhaustive theories have helped create a contem-porary art world with no defining formal strategies or move-ments. Like the current American political climate, much of the critical discussion on art often leads to a series of unsus-tainable pronouncements on digital whatnot and advertorial rallying cries from a pit to sell, sell, sell. Yet, for better and for worse, in equal doses, aesthetic arguments and constructive opinions (especially those surrounding globalism) provide enough food for thought to keep the juggernaut moving. Granted, the politics of racism have also changed, but the tug-of-war over the black image in art and beyond has intensified.

A consideration of "contemporary" figurative and social realism in the charged contexts of black artists takes on a slightly different background, if not a whole new set of rules. Though derogatory imagery of blacks in visual art has been a potent "ready-made vocabulary of racialized signs," as Greg Tate notes, their use by some very good artists recently got them "*black*listed" by other black artists.[3] As evidenced by the recent Academy Awards where Halle Berry became the first black woman to win as a starring actress, the contested terrain of mediated imagery is also national front-page news and fodder for the nightly talk shows.

These issues go further than a discussion on race

ROMARE BEARDEN
Farmer, 1968
Collection of The Studio Museum
in Harlem

to an often elitist art world that continuously teeters between boundaries of "high" and "low," encouraging the construction of often useless conversational polarities. "But is it art?" Simple questions like that resonate with complexity when we take into account that African art's incorporation into modernism began with the cultural sampling of artists like Picasso. Modernists make high art by taking the materials of low or mass culture and incorporating them until they are unrecognizable. If you don't believe in white supremacy as an agent of culture and the imagistic power of figurative painting in the relatively new millennium, see last year's blockbuster *Norman Rockwell* exhibition. Rockwell, who admittedly created work for reproduction, not to be seen as art objects per se, is a rare example of low art perceived as high art. The show traveled to Atlanta, Chicago, Washington, D.C., San Diego, Phoenix, and Stockbridge, Massachusetts before finishing at the Guggenheim in New York this past March. Rockwell, a middling painter of caricature at best, was given the full-on treatment—albeit posthumously. He is now welcomed into the sanctimonious halls that his "art for the people" stood against while he was alive.

Yet, representation and narrative have not been abandoned in the way suggested by Ellison. Rather, the favored modes of representation happen to be adaptations of what was once considered the media and tools of the filmmaker. Thus, most large exhibitions of contemporary art contain more cold screens than warm paintings. So, there is something almost quaint about a group exhibition dedicated solely to original paintings of realist images. One such show of younger artists would include the work of John Currin. Beyond that, the art world's current relationship with figurative art is fickle at best. It seems like, as Thomas Crow says, the "devaluation of subject matter has left functional modes of figurative representation no claim to the status of art at all."[4] But there is a generation of figurative artists working on a parallel path to today's neo-conceptualists. While Bearden has now gone down in history for his gorgeous collages of black people in daily circumstances, contemporary black figurative art picks up where he left off. The dialogue around the artists involves Old Masters like those who've inspired Currin: Manet, Fragonard, Bouchet, and Courbet; and Old Masters like Johnston, Tanner, Douglass, Lawrence, Bearden, and Thompson.

Coupled with last year's *Freestyle* exhibition of young artists in varied media and its bold pronouncement "Post-Black," *Black Romantic* takes another pulse on contemporary art.[5] Based in two-dimensional pictures, the work of many of these artists also appears in reproductive form on countless sidewalks in urban America. The mass medium approach of prints and posters in some of these artists' work points to two figurative realists whose artworks' dissemination comes to mind here: Ernie Barnes and Varnette Honeywood. Both artists provided the visual art backdrops for popular television shows in the 1970s and 1980s, *Good Times* and *The Cosby Show* respectively. Now, Barnes's mannerist black bodies find resonance in the hip hop generation as visual accompaniment to flyers and posters. Honeywood's work, like that of Bearden, is a staple of black business offices. *'Free Within Ourselves To Conserve a Legacy'* has been a black modus operandi functioning in various fields until the wider and more commercial machinery of American systems comes calling. Negro Leagues, Masonic Lodges, jook joints, and house parties have all fostered dynamic forms of social interaction within the segregated sphere of the collective. Poetry readings weren't Def until HBO brokered the deal.

So, if the conspiracy of excellence is a federation of eyes, then maybe we're talking about two pairs of eyes.

Franklin Sirmans would like to thank AM, JL, CG.

1. Ralph Ellison, "The Art of Romare Bearden," in *Going to the Territory* (New York: Vintage, 1987), 230.
2. The use of the term black throughout this text should be read in a non-essentializing (British) sense of the word, covering more than those of African descent.
3. Greg Tate, "In Praise of Shadow Boxers: The Crises of the Originality and Authority in African-American Art vs. The Wu-Tang Clan," in *Other Narratives* (Houston: Contemporary Art Museum, 1999), 39.
4. Thomas Crow, "The Simple Life: Pastoralism and the Persistance of Genre in Recent Art," in *Modern Art in the Common Culture* (New Haven and London: Yale University Press, 1996), 176.
5. Romanticism: an incurable illness with a plethora of good sife effects.

All Good

Interview with Alonzo Adams

LERONN BROOKS

Inspired by the everyday sights and sounds of black life, Alonzo Adams creates intimate portraits that acknowledge and affirm specific moments and characteristics of the black American experience. Painting professionally for almost twenty years, he has achieved a strong base of support in working and middle class communities, as well as among prominent celebrities and athletes—many of whom are new collectors and not engaged in highbrow art world discourses. In March 2002, before the Black Romantic show at the Studio Museum in Harlem, I had the opportunity to sit down and talk with the artist.

LeRonn Brooks: How you feeling? Things good?

Alonzo Adams: Everything is real good.

LB: So, where are you from?

AA: I originally came up in Harlem.

LB: Uptown?

AA: Uptown! Then grew up in Plainfield, New Jersey.

LB: When did you start painting?

AA: Well, I've been drawing since I came out the womb, but I really started painting my freshman year in college. That was when I was like seriously, "I'm going to do a painting." But I've been drawing ever since I was a child. I started doing it professionally back in '84.

LB: '84?

AA: Yeah, making a living at it.

LB: Where did you go to school?

AA: I went to Rutgers undergraduate and then the University of Pennsylvania for grad school.

LB: How was the art program at Rutgers?

AA: Rutgers had a decent program when I was there; I believe it could be tweaked a little bit, in all honesty.

LB: How so?

AA: To me, there's too many students graduating from art programs without the technical skills to actually go out and make a living at it. A lot of universities are passing students along making them feel like they are ready for the world. They get out there, find that they can't make a living as an artist, and they end up doing other things. I can't see spending all that money and not being totally prepared to get out there and make a living at it. If that's the case, then prepare them for other jobs in the art field and tell them to keep their love for art too. If you are going to a school and learning traditional techniques, don't get them out there thinking they're ready, and they haven't even grasped the fundamentals yet. So I have a problem with that, not just with Rutgers, but art schools in general.

LB: That's pretty old school.

AA: Yeah, well you've got to have the ingredients in order to bake the cake, you know what I mean? You've got to have the right ingredients or the cake is gonna fall, and that's what I feel like is happening to a lot of young students coming out of art schools.

LB: Your work is pretty realistic and figurative. Before the interview we were talking about the relevance of abstraction versus realism, in relation to what you, as an artist, want to capture. Do you want to elaborate on that?

AA: I've pretty much established myself as a representational artist, a realist, but now my work is starting to take on an impressionistic type of look. That is because of my travels throughout the world, absorbing other art and different techniques. When you go out there, you are like a sponge, and then when you go back to the studio, you wring it out. So that is what is happening with me. I think my work has taken on an impressionistic type of look.

LB: You said impressionistic, who are some of your influences?

AA: Well, everyone knows I love Charles White, I'm a big Charles White fan. I'm a big [Henry Ossawa] Tanner fan and I'm a big fan of Thomas Eakins, his teacher. I was a big fan of Rembrandt. There was also a French artist named Jean Millet, I love his work. Believe it or not, I like a lot of contemporary Asian artists, too. I love their work, the ones who work in the traditional realistic and impressionistic styles also. I love their application of paint, color, and space. I come from a traditional school as far as thinking.

LB: You deal with direct experiences of black life…?

AA: Oh yeah, most of my work I consider is like the autobiography of my life. People say, "Where is your inspiration?" And I'm like, "LIFE." You know, relationships, things I did as a child, things I see on the street. Whatever I'm going through in my life at a particular moment, it usually comes out in my work somehow or someway.

LB: On your web site, you say you want to escape, that your art is a way of escaping from a chaotic world, but your images deal directly with the world. How do you relate the two?

AA: When I paint, it's like therapy. Regardless of what is going on in my life, when I get in that studio, it's like a calm takes over me. When I say that I escape from a chaotic world, I mean that when I go into the studio, I put on some music.

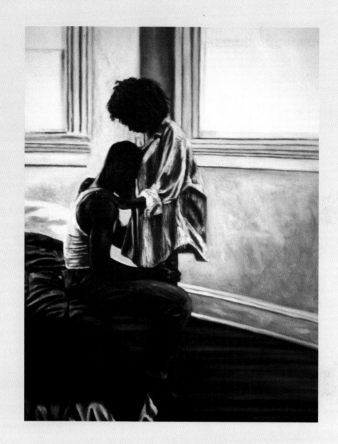

ALONZO ADAMS
Lay Your Heavy Burdens Down, 1990

35

I usually start with rap—that's my caffeine to get me juiced up. I put on DMX or Jay-Z or Nas or any of those young rappers, and they get me all amped up to get out there. But by the end of the night, I've mellowed out to some old R&B and jazz. You might hear Wynton playing or an old LTD or Isley Brothers or something like that, but it is a transition that I have gone through. When I walk into my studio, it's almost like when I used to walk into the gym. I studied martial arts for a number of years and when you walk in, you wipe your feet off, you give praise to the creator—it's almost like a sanctuary. Whatever is going on outside, you leave it out there. I paint late at night usually; you know, when the whole world is asleep, so the phone is not ringing off the hook and whatever is going on out there is out there, out of my studio. That's what I mean when I say escape from a chaotic world, but still portraying what I see in everyday life.

LB: Some of your images deal with intimacy and love and are so personal. So beyond a chaotic world there is something so personal that comes out.

AA: Well, it's also stuff I have lived, relationships where I 'lay every burden down' [referring to the title of a painting]. The reason that was such a huge success is because every brother can relate to it. Every brother can relate to having the weight of the world on his shoulders and having his lady say, "Hey, it's alright." Most of the time we like to believe we are macho, we are strong. Every brother wants to lay his heavy burdens down and every sister loves to be there for her man. They want us to be strong for them, but they want to nurture us too. Brothers can relate to *Lay Your Heavy Burdens Down*. There are other pieces I've done, like *That Love Thing*, that say, "you know, we've been through the storm, now we are enjoying that moment of love." All my paintings deal with relationships and things that I have personally felt.

LB: They communicate to a lot of people too. I was reading

from your collector's list, all the people who have bought your work. What is your relationship with your collectors like?

AA: Phenomenal, I mean everyone can relate to love. Put it this way, a lot of athletes and celebrities collect my work; usually, once it's put in front of them, they want it. I just finished selling several pieces to some of the ball players, and, usually, as soon as they see it, it's like: "I've got to get some of this." I remember this one brother who said he wasn't into art. I was at a show and he just happened to be there, and I said, "Hey, what's going on, how you doing?" He was standing by the door like he was ready to leave, but his wife was there. I said, "Man, why don't you go check out the artwork." He said, "Ahhh, I ain't into art." And suddenly, inside, he was like, "I love that!" So I'm thinking—wait a minute, hold on, this is the same brother who says he isn't into art? Most people have to be exposed to it. My whole thing is that everyone has walls. What are you going to put on your walls? Why not Alonzo Adams? So it's just an educational process; it's just a matter of exposing them to it and exposing them to what it means to be a collector.

LB: The art historian David Driskell has been commenting on your work. What is your relationship to him?

AA: Dr. Driskell is my mentor. I don't know if you know this, but Bill Cosby put me through grad school and David Driskell was my validation; I had to go through him. It was almost like a screening process. I had to go to him [Driskell] and talk to him and let him see my work and get a feel for what was in my heart, where I wanted to go, what I wanted to do, before Mr. Cosby could say, "Okay, I'll do this for you." So all the way through grad school he was kind of watching my growth, seeing where my work was headed, and what I was trying to say with my work. That's what that relationship grew out of.

LB: The show that your work is in, *Black Romantic*, is at The Studio Museum in Harlem, a major venue. How do you

find your whole relationship with the "mainstream" art world? Where do you usually show your work?

AA: I'm usually in galleries across the country. I do galleries and private showings and stuff like that. Right now, my desire is—I talk about this all the time, but I mean it from the heart. I know how to make money with art, but what I want to make is history—I want to be in the permanent collections of the museums, the major collectors and everything. I think the *Black Romantic* show is such an important show, and the venue, The Studio Museum in Harlem, you couldn't ask for a better place. Some of the greatest have come through there—Charles White, [Romare] Bearden, and Jacob Lawrence. They have all been through The Studio Museum in Harlem. To me it is an honor to be a part of that show and it's another step in my journey to where I want to go. One day I am hoping to do a one man exhibition at The Studio Museum, because my dreams are to do stuff like that, to have my work at the Met [Metropolitan Museum of Art], and a couple other major galleries here in New York. Because, when you have done that, then you start a legacy, then you are dealing with longevity. I tell people all the time that there is a difference between going out and getting something at McDonald's and going to your mom's house and putting your feet under the table and eating a good home cooked meal. We live in a fast food society and I fight that constantly because I want longevity. I want to feed people food for the soul in my work. I want to have them seeing work that will stand the test of time, not like, "Oh, that artist was hot in the '80s, he was hot in the '90s." I want work that will be timeless. Eating mom's food never gets old. You are raised off it. It will never get old. I don't care what culinary experience you have had in life, mom's cooking will always be mom's cooking, you will always love to come home to mom's house. I want people to feel that way about my art. You can go through changes—you might

collect this one, you might collect that one, but you will always have Alonzo Adams in your stable because it is food for the soul; it's timeless, regardless of what is changing around you.

The black art market is such a decorative market. A lot of people getting caught up with colors, because we as black people just started collecting art maybe twenty years ago, anywhere between fifteen to twenty years ago. *The Cosby Show* really blew up collecting art. Before then people had landscapes, or pictures of Martin Luther King, John F. Kennedy and Robert F. Kennedy, and one picture of Jesus, and that was it. Now all of sudden it's very rare that you walk into a black home and not see African-American art on the walls. I want to be a part of that whole odyssey. People might collect one of my prints, but then they will work their way up to one of my originals. But I don't want to saturate the market with these high numbered edition prints or throw a lot of red into my paintings because it may be hot right now. I just like to paint scenes of everyday life. Hopefully, when I do that, it's something that someone can relate to. It would be easy for me to do the cutesy scenes and this and that cause right now black folks are still really naive about what is good art. People often think that, 'Hey, that picture of the father sitting with the son is great; I like that, I can relate to it—regardless of whether it is painted well, you know, as long as it is a picture of a father and son— I am going to buy it.' What I am trying to do is educate people about what a good painting is, to get past the subject matter: look at the texture, look at the composition, look at the application of the paint, you know, all that. I'm trying to bring people along in that way too, to know when they are looking at good art and good collectible art—the paper it is on, the materials used, how it's preserved—because so many people are getting duped into buying what they think is great art. I feel for some people when they find out what they got, 'I spent what? This is what? A regular print?' There's going to be a lot

of angry folks out there when they really get educated as far as to what they are buying.

LB: How do you find your relationship with the black press?

AA: Oh good, real good. I just don't seek it out. I've got to find somebody to do my marketing, because I want to paint and let everything else kind of work its way out. If I wanted to, I could seek out this magazine and that magazine and get an article, but I don't have time for all that. I just want to paint and let everything else fall where it may. But the black press has been good to me, real good to me. They just did an article on me in *Upscale* magazine; they just mentioned me in *Black Enterprise* magazine. I've been in *Essence* and most of the major magazines and newspapers, so it's been good.

LB: So is that how the majority of people find out about you or is it through word of mouth?

AA: Word of mouth usually, or they have seen my work somewhere. I have a big show here in New York. I'm doing it on April 21, 2002. It is usually done in October or November, but I didn't do it last year because I got married and then September 11th happened, so people weren't really in the right frame of mind to be going out in New York and hanging out at an art show. Plus, people didn't have any money and were worried about what their future was going to be. So I pushed that show back to April 2002. The beauty of that is that I will be able to tell a lot of folks about what is going on at The Studio Museum in Harlem, so they can get up there and support that show. Life, I really can't complain about it. I'm really happy with the growth of my work, with more and more collectors coming on board. A lot of young people are starting to really get into buying and they don't really want prints, they want originals. So it's all good right now, it's all good.

38

Another Hero
Interview with Dean Mitchell

REGINA L. WOODS

Regina L. Woods: Kerry James Marshall has said that after Abstract Expressionism, many artists haven't been trained to manipulate materials. Instead, they have been taught to manipulate ideas and concepts…and because of it, contemporary art has suffered.

Dean Mitchell: It's probably true. After one of my shows, a critic commented that it was nice to see an artist with the ability to manipulate materials and who was not limited to poorly constructed conceptual gimmicks. I look at it like this, visual art is supposed to be visual. If you really have to explain every corner of it, you might as well have been a writer. Once the writing overrides the works ability to communicate visually, it is not successful to me.

RW: Did you run across this problem with some of your students when you were teaching? Were students interested in manipulating materials or more interested in the concepts?

DM: Actually, they were interested in developing their ability to paint. In fact, I ended up teaching because a lot of the professors who were graduates of these Ivy League schools couldn't draw. They could not draw.

RW: What kind of art moves you?

DM: I like non-objective works. Even though I do academic work, my compositions have a pretty heavy abstract quality to them. It's also apparent in how I handle space, even though it is very academic. I have a great deal of appreciation for abstract work. I like all kinds of art. Some of my oil paintings, especially, have an abstract quality. The works in this show don't, but in some of my other works, you can see it.

RW: Who are some of the artists from the past and present who you most admire?

DM: Oh, from the past, I like Rembrandt…

RW: Why Rembrandt?

DM: His handling of light and how he takes the viewer beyond the figure. There's a mystery to some of the portraiture work. I've always been fascinated with particularly his later work. His earlier works were more classical, very refined and modeled. His later works were very impressionistic. The Impressionists weren't so new. Rembrandt was making impressionistic paintings in the seventeenth century. The only thing the Impressionists did differently was to take you outside to a natural setting and used color against color. Rembrandt used light against dark so you felt the tonal contrasts in the work rather than the color. With the Impressionists, you felt the color, the light, and the atmosphere.

RW: Is there anyone else?

DM: There is Degas.

RW: What about Degas?

DM: Oh, you know, if you look at his work you will see…Motherwell, DeKooning…you will see a lot of the modern artists. If you were to eliminate what is real to the eye, particularly in the figures, you will see nothing but shape and form and movement. This is basically what a lot of Abstract Expressionism was about—space and surface and texture. It's all in Degas's work. There is a heavy abstraction to his abrupt use of edges, his placement, the way he moves you around with positive and negative spaces. It fascinates me—the bird's eye perspective, it is always very interesting. I also relate to the fact that he dealt with ordinary people. Of course, Henry

DEAN MITCHELL
Boundary, 1995

Tanner is always one of my favorites.

RW: When I look at Tanner, Rembrandt automatically comes to mind as a source. The Old Testament work and the light that he uses…the warmth of it.

DM: Oh yes, and I like Jacob Lawrence, Romare Bearden.

RW: Are there others?

DM: Oh, Motherwell. I think his sense of design was just exquisite in terms of how he handled color and his subtle touches. To me, he was sort an abstract Rembrandt. He dealt with the mystery of those dark spaces, popping color here and there. I like the idea of the collaged surfaces, the different surfaces that he would apply, maybe some pages of a book on a surface. And I like Jasper Johns's work as well, because of the layering of things; again this had a mystery too.

RW: Talk to me about Richard Diebenkorn. You mentioned him earlier. I am a huge fan of his Ocean Park series. I love the way he layers thin washes of oil paint and allows you to see beneath the paint. I'm drawn to the transparent unfinished quality in the works. He applies oils as if he's using watercolors, pastels, or gouache. To me, there is a sense of chaos at bay.

DM: I like the way he handled some of his figurative work. There's sort of an abrupt energy in his brushwork that I really, really like. And some of his landscapes stuff, that sense of space, color, and warmth…it is just really fascinating how he handles some of his urban landscapes, how he places the figures. Of course the figure against the window thing is sort of an old idea, Winslow Homer did it a lot, who else…

RW: Vermeer.

DM: Exactly. A lot of them used the window thing…the space thing. Diebenkorn has done that, except of course in a more contemporary way in terms of the way he handles surface. It's still the same old idea rehashed, but more contemporary. So I like that—taking an old idea and making it fresh

again, making it relevant to the present moment.

RW: Who are the writers, musicians, or cooks who interest you?

DM: Musicians. Hey, I'm a jazz man. But, I also like some rhythm and blues. I have to admit, I love myself some James Brown; I grew up with James. I love the energy of James Brown. Let me say, I love Billie Holiday. I love Billie Holiday!

RW: What does Billie do for you?

DM: She can grab a part of you and make you feel every word. She can take you to a place where you might be uncomfortable…and at the same time let you know that you are going to emerge from the unpleasantness. I just love her.

RW: What are some of the philosophical, critical, cultural or political issues that influence your work, your life, or even the way you eat your breakfast?

DM: I grew up in the South and I worked in tobacco–

RW: Oh did you? Tobacco?

DM: Yeah! I'm a country boy. Some people see me and think I am a city person, but I am a little country guy. I will rent a Penske truck, load up a hundred paintings on back of it, and drive eight, nine hundred miles. Some people are fascinated by it. I say, "Yeah, I'll drive my own stuff." A country boy don't mind. When I was growing up, my grandmother worked for ten or fifteen dollars a week. That kind of did a lot to me, growing up that way. My grandmother was always talking about getting a good education and trying to better your life. Because of her I always wanted to do well. We used to sit and watch Dr. King when he was making his speeches, and you just wanted to figure out a way to better yourself. Even if you had a little, it didn't make you feel bad that you had a little. You just kind of took the little that you had and built on it.

I grew up during the race riots. Seeing how black people were positioned in the society because of their lack of economic means tore at me a little bit. I know when I first started painting, the black figures were not selling very rapidly, nobody was knocking to buy those. I continued to paint them whether people bought them or not. At that point, the art thing became a very strange thing to me, as I learned more about it and the significance of museums, how they house our finest treasures. These are the archives for our nation. When I'd go in, I didn't see anything that reflected us. We were not a part of this wonderful archive. I saw all these paintings of Caucasian people. I could not understand. I thought that maybe art would be slightly different. But I found out that it wasn't and that there was a class thing.

RW: Absolutely.

DM: I was going to museums trying to figure out why certain artists were in museums and why certain artists were not. I realized that a lot of them, like Winslow Homer, were from aristocratic families. Since I am not from an aristocratic family, I had to figure out another approach. Then I started reading about all these prestigious societies they belonged to, like the American Watercolor Society, the National Academy of Art, and the Allied Arts of America. I thought, 'So this is what you call credentials.' Winslow Homer was a member. Georgia O'Keefe. Andrew Wyeth. So, while I was a senior at Columbus College of Art and Design, I entered a painting to a show at the American Watercolor Society. My painting was accepted into the show. The first time I got elected as a member of the American Watercolor Society I was about 28. I went up to be inducted, someone asked quite disturbed, "How could you possibly be a member? You're only 28, when could you have possibly entered this?" And she went on and on and on, really quite disturbed that I had gotten accepted.

RW: What other obstacles, if any, have you had to address as an artist?

DM: The race thing kept coming up. So I thought my best bet is to enter lots of these juried shows, build my reputation,

41

and hopefully win, and not go so people wouldn't see that I was African American. I was hoping that they would look at the work and judge it on its merits rather than looking at my race. It worked. I was winning so many awards, top prizes. Because I was winning, magazines kept knocking at my door. In the beginning I didn't respond because they always wanted to run a photo, and I didn't want them to find out I was black…. I was this mysterious guy who was always winning but never showing up to accept the prize.

RW: It sounds like a story from long time ago; maybe from Henry Tanner's or Augusta Savage's or Lois Mailou Jones's era.

DM: I know it sounds kind of weird, but it's true. I was living off the prize money. I couldn't really sell enough of my work in the galleries to make a living. With the award money from shows I was making maybe four or five thousand dollars a month. This was much more than I was earning making cards for Hallmark.

RW: It is really interesting how you worked the market to your benefit without having to compromise your passion. When you were entering these shows, were you entering black subjects?

DM: Everything. Black people, landscapes…

RW: What is your mission as an artist? Why do you do what you do?

DM: That is interesting. I was talking to one writer; I was talking about race, and American art, and how by the grace of God I have managed to have an eclectic audience, anybody really. But one thing that I've always hoped is that I could help us get rid of this demon of racism. I think art has a way of bridging and healing wounds. I would like to be a catalyst for that.

I decided in art school to be the best at what I do. I didn't know what the definition of "black art" was or what political issues people were looking for in art. But whatever I choose to go in, whether it is academic painting, contemporary—whatever kind of art it was, I had to be the best at it. I was going after the heart of what is considered the best in American art.

RW: How do you define "the best"?

DM: You know there is something about works of art… there are nuances. The nuances and subtleties. I remember listening to the dean of the school, Dean Cozani, an Italian. He was always saying that the secret of art is in the subtleties and tonalities of color. They are the mysteries. I'd listen to that. The subtle nuances make something exquisite, and it captures you. Not always the things that are so dramatic, but the subtle nuances. The in-between things. When you are painting a subject you are really trying to capture those subtle treasures of life. Any artist who loves what he does, who pours himself into it, searches for those subtleties. I don't care what race or creed or culture, people are going to respond to that. There is something god-like about it that just pulls you in. It just grabs your soul.

RW: How do you achieve this in your paintings?

DM: A keen eye for subject, for that which is pure and real to the naked eye.

RW: What inspires your work?

DM: I tend to focus on common people, laborers. The common man carries society. So the real heroes are the common people. My grandmother who had a fourth grade education had enough foresight and vision to tell me to pursue art. She had the wisdom that sent me over the threshold to pursue art. Not just the mere education. I am interested in portraying that which is long lasting, not just in style.

Lately, I've been buying a lot of books on African masks. I was visiting a shop in East Orange, New Jersey—a wonderful shop of African artifacts—and I bought a whole bunch of stuff and had it shipped back. I was really fascinated by the design of the masks and instruments. The wood, the rich textures, just

exquisite stuff. I have been sketching them and making paintings of them. I know that this stuff is going to emerge in my work, I can feel it coming on…

RW: Are there any technical or conceptual challenges that you are presently facing in your work?

DM: In the early work some of the paint is quite thinly applied. Recently I've been doing more body, more layering of the color, sort of thickening it up and seeing what body paint does. I've wanted to work larger, particularly with the African-American male figure. I have a tremendous following of buyers for the female figure. The Caucasian will buy the female figure, in particular the elderly female figures. A lady bought one of Rowena, my elderly friend who has since passed. Rowena would wear these wonderful hats. They tend to really love that particular subject for some reason or another. This is not true for the male figure, and the younger female figure. The woman who bought Rowena came again to buy a portrait of my cousin Caroline, but was uncertain because she said, "she just looks a little snooty to me." I thought, "snooty"? They buy the ones that have a bit of a religious tone to them. But the ones that have this regal or majestic power tend to make them uncomfortable. Maybe the pieces have a little too much presence.

In 1990, I entered two black male images to a juried exhibition. One was *The Usher* and the other was of my uncle dying of cancer. After seeing the paintings, an art professor from the University of California Berkeley said to me, "You are trying to present an image in American art, you are trying to lift people up; they are not ready for that." He was right.

However, the one of my uncle did sell to a physician in California. But, two years later, during the time I was president of the Santa Fe Watercolor society, he wanted to give the painting back. He said, "I've got it in my office, and it is just driving people crazy. Can you give me something else, because I don't think I can live with it." I traded it for something else and got it back. Luckily it ended up at the Kemper Museum. But, it was interesting to see the reaction to the male image again.

RW: What is the most important quality of the subjects that you paint?

DM: I think it's the spirit. Critics have told me that I am an extraordinary draftsman, but I think that people are most moved by the spirit of the people. That is what I think holds them. I think it is the eyes, a lot of it is.

Strong Men Keep Comin'
Interview with Kadir Nelson

MALIK GAINES

The strong men keep a-comin' on
The strong men git stronger...
 —Sterling Brown

Malik Gaines: I'm completely impressed by the NAACP Image Award that you just received in recognition of your illustrations for Will Smith's children's book, *Just the Two of Us*. What was that experience like?

Kadir Nelson: Well, it was exciting and nerve-racking at the same time, partly because I wasn't one of the celebrities there. No one was like, "wow, there goes Kadir Nelson." But it was exciting; you could do a little bit of star watching.

MG: Did you go up onstage to accept the award?

KN: Yeah, I went up and accepted the award, but they cut me out of that part [of the broadcast].

MG: Well, congratulations. This was not your first star encounter: you've worked on production drawings for Steven Spielberg's film *Amistad*, you've worked on books with Debbie Allen and others. What is it like, as an artist, to be thrust into this adjunct-celebrity position?

KN: It's exciting. It's not one of those things you really expect to happen, but when it does, it just makes the experience that much more incredible.

MG: Are you still impressed by stars?

KN: It really depends on who it is.

MG: Celebrity aside, let's talk about you and your work. What can you point to in your history that has brought you to where you are?

KN: Having a supportive mother. She always gave me plenty of material to work with. All she really needed to give me was a thick pack of blank paper. And my uncle, Michael Morris, was an artist and an art teacher. When I was about 11 he took me under his wing for the summer; we spent the summer drawing and he taught me a lot. He gave me my foundation.

MG: You were an Illustration major at the Pratt Institute and you finished in 1996, the same year I finished college. What was that education like?

KN: Pratt was incredible. My art had been pretty realistic, it was pretty tight and heavily rendered. Pratt loosened me up, both my personality and my artwork, which was exactly what I needed. Before I went to school, I only looked at three different artists: one being my uncle, the other Ernie Barnes, and the other was Boris Vallejo, who does fantastic, science-fiction work, like Conan the Barbarian, really muscle-bound men and women. His style is really slick. Ernie Barnes does these elongated figures. And my uncle would do a ton of different things like science fiction and really heartfelt, historical stuff. All of that merged into one for me.

MG: In looking at your work, I've noticed that you sometimes use realistic imagery, sometimes the subjects are hyper-real, sometimes surreal. Are these style shifts characteristic of your influences?

KN: Probably, there were plenty of instructors at Pratt who

helped me determine what kind of artist I wanted to be, specifically one instructor, his name was Dave Passalaqua. He always emphasized being versatile and not being stuck in one style, and that really attracted me because I don't want to do the same thing over and over. If you are bored, then the person looking at the work is going to be bored also.

MG: Among your influences, you've mentioned Ernie Barnes, you also have cited M.C. Wyeth and Norman Rockwell. What did you learn from these artists?

KN: Ernie Barnes was, besides my uncle, the first African-American artist whose style I really liked and emulated. I think a lot people in my generation gravitated toward his work because it had a lot of emotion, it was just fun to look at. You would look at it and smile. M.C. Wyeth and Rockwell, both of those guys were incredible painters. Wyeth used a lot of color and texture, and Rockwell, he was just a hell of painter. He was a very good draftsman. I'm not so drawn to the expressions on the faces. I think they can be a little bit over the top, but I really like how he expressed some of his ideas. The *Four Freedoms* were just incredible. His compositions are very well thought out and nothing is unintentional.

MG: Like some of your influences, your illustration and painting skills seem to have both commercial and fine art applications. How do you negotiate the distinction between these two areas? Is one truly different from the other?

KN: With commercial art, I try to stay away from putting a Coke can in somebody's hand or a cigarette in someone's mouth. It has come up that I've had to put the logo in the actual piece, though that is pretty rare. I've only done that a couple of times and I try to do it in a way that is not so heavy-handed. As far as walking that line between fine art and commercial art, I think good art is good art, period. If you are doing good art, people are going to respond to it.

MG: What is good art? What kind of criteria do you use to make that determination in your own work?

KN: If it gets the point across that I'm trying to make clear, then I've been successful. But it's not just getting the point across, it's a matter of how you did it. Say you are trying to express a certain feeling or express a certain emotion. If it's done in a way that pleases you and you are able to keep your integrity as an artist, I think that you have pretty much been successful with that piece.

MG: This notion of "getting a point across" is something I always encounter as both an art writer and a teacher. Some people paint, for example, as an articulation of a particular set of theories or ideologies or as a recontextualization of certain art historical models, while others paint because they are driven to put color on a canvas. Most, I think, fall somewhere in the middle. Where do you find yourself in this dichotomy of concept and expression, which, in a very reductive way, could be talked about as thinking versus feeling?

KN: Honestly, I try to do them both. Every time I sit down at the canvas, I want the piece to have some type of meaning. I don't just want to put paint on a canvas or just paint a pretty picture. It doesn't have to have any social relevance, but it has to communicate some kind of expression or provide some kind of hope or something that is meaningful. Otherwise, it's just like talking and saying nothing.

MG: Does your intended meaning ever take on a political position?

KN: I don't ever have plans where I think: I really want to shake things up politically. If there is something that really means something to me, and I want to try to do something about it in my own small way, then I will try and put it on canvas. If there is something I feel needs to be said and I can say it, then I will. But I don't go out of my way to do it.

MG: We have such a complex history of racist representation in American popular media, and it seems that part of your

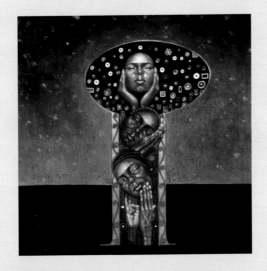

KADIR NELSON
Beautiful, 1999

program is to counter this deleterious history, which is still ongoing, with wholly affirmative representations of black people.

KN: Definitely, I want to give African-American people some sense of nobility and integrity. I don't want any negative images of African-American people, we see that enough. If anyone is going to paint African-American people in a positive light, then I am going to do it. Who else is going to do it besides us?

MG: I think back to when *The Cosby Show* first aired on television, we were both kids then. Bill Cosby was saying that he'd had enough of the images of African Americans on television and that he wanted to portray a happy, healthy, bourgeoisie family. He got a lot of criticism from within African-American communities, many of whom were suggesting that this isn't what our real experience is in this country. Have you ever received that sort of criticism?

KN: No. The only criticism I ever get, and I don't know if it is a criticism, is when they say: "Where are the women? We want some more women represented." And I agree with them. I just have to do a piece that would be in line with what my feelings are about women. Honestly, all the jobs I've gotten have been basically about men, a lot of sports or music or historical stuff, and I haven't really found that series, or that image, that I want to do yet. I used to paint women a lot actually. I was a teen and a lot of it was very sexual; I don't want that to be the only way that women are represented in my work.

MG: Do you see yourself as operating as part of any particular movement or tradition?

KN: As an artist, you pretty much work in a vacuum and you are not aware of much going on outside of the studio. I'm not a part of any clique or group or what have you. Honestly, I don't see any artists doing things along the same lines as me that are my age. I can't really think of anyone else out there that I would pair myself with, which is good. I am anxious to see who else is in the *Black Romantic* show and to see how their work relates to mine.

MG: Let me ask you about this painting *Africa*. It presents a silhouette in front of a vast and open sky. First of all, Africa is a continent. There is no land in this picture.

KN: It was one of those pieces that you see pretty much in its entirety in your imagination, it just kind of hit me and I scribbled it down, and it just became that. I gave it that title because that is the feeling I get when I think of the word "Africa." Basically, it's just a man looking up into a vast sky. This bird flying overhead represents his spirit. He could be on a slave ship, could be on a canoe, on land, it doesn't really matter.

MG: That's a very nice painting. What about the painting called *Right Wing*? I think of a conservative republican, but it's

a basketball image.

KN: Yeah, it's not even related to that at all. I thought about that afterwards and realized people will just have to think that, but that's not what it's about. Basically there was a poster of Michael Jordan. He had his arms spread, it was called *Wings*. He's jumping really high, people thought he was flying. *Right Wing* was just a take on that—this guys right wing holding the ball.

MG: Was that for a specific project?

KN: That was for Nike, for a t-shirt; but they didn't use it.

MG: There are several other works featuring basketball: *Next Five*, *Big Men*, and *The Rucker*. Were these for Nike also?

KN: *Next Five* was for *Men's Journal* and *The Rucker* was for *Vibe*. *Big Men* was for the Nike project.

MG: Did these people ask you specifically for sports?

KN: They wanted basketball. The funny thing is that they didn't use the finished pieces; they just used the sketches, which is weird, but that's just the way it went.

MG: I guess they will get a second life in this show.

KN: Yeah and that's great.

MG: Is basketball something you would be drawn to normally, or were you just meeting the product requirements?

KN: Yeah, I play basketball. A lot of the work I've done has been basketball related. I don't really go after jobs that I would have to do a basketball painting for, it just kind of ended up that way.

MG: The style is somewhat realistic, but the figures appear idealized and unnaturally strong.

KN: I like to try to show the strength of people's spirits. Basically, that's what it's all about for me. I like to show people who are strong.

MG: What are you working on now?

KN: One thing is an album cover for Swizz Beatz, this producer who has this whole Ruff Ryders camp. The big thing I'm working on and really excited about is a book about the Negro baseball leagues. I'm writing it and doing the art for it.

MG: How is the writing coming?

KN: Slowly, very slowly. I haven't really been writing much; now and then I've been writing in my journal. I've been doing a lot of research and reading. When I'm finished with all my research, or finished enough, then I will sit down and fill in the gaps.

MG: Is there a specific focus to the book?

KN: It's written in a first-hand perspective. It explains different events or experiences, like when they were traveling on the road, or when they faced segregation, or describing owners or certain players who stood out above others, sort of 'this is the way it was for us.' It's really exciting, a lot of really interesting material to work with.

MG: You've used a lot of sports and music imagery in your work. These are areas that African Americans are stereotypically involved in, but at the same time areas in which African Americans have been some of the most important innovators. Do you ever worry about the use of traditional, stereotypical contexts for your black subjects?

KN: It really doesn't matter to me. It's funny you asked that because Spike Lee called me several months ago, I don't know how long ago, it might have been a year ago. He wanted me to do a movie poster for *Bamboozled*. He wanted it to be realistically painted instead of photographed, but he ended up using photographs. I was like, "Man, that was as stereotypical as you can get." But that was the point of the movie. As far as my other work, I don't really worry about further amplifying that whole stereotype of black folks in music and sports. I don't worry about people looking at my work and thinking he only does this or that, because I don't only do this or that.

MG: Are you going to go to New York to see the show?

KN: Oh, I wouldn't miss it.

47

Faux Real

Interview with Kehinde Wiley

CHRISTINE Y. KIM

Christine Y. Kim: How long have you been painting?

Kehinde Wiley: Since I was 11. My mother took me to art classes on the weekends. As a kid growing up in Los Angeles in the 1980s, my mom took me to museums too. She is a linguist, and art was another language to her. I loved the Huntington Library galleries. Joshua Reynolds, Thomas Gainsborough, and John Constable were some of my favorites.

CYK: The eighteenth-century British masters and the Royal Academy…? What was it about these works that you were so drawn to?

KW: The imagery. It was sheer spectacle, and of course beauty. When I started painting, I started looking at technical proficiency, manipulation of paint, color and composition. The portraits were hyperreal. All the detail on the face was really well crafted, and the brushwork, the clothing, and the landscape were more fluid and playful. Since I felt somewhat removed from the imagery, personally and culturally, I had a scientific approach and aesthetic fascination with the paintings. That distance gave me a removed freedom. It wasn't until later that I started thinking about issues of desire, objectification, and fantasy in portraiture…and of course colonialism. But I was just an adolescent, and these paintings were just powerful.

CYK: Powerful aesthetically, in all the ways that you mentioned, as monumental, grandiose, sheer spectacle, as well as being eighteenth-century masterpieces of Romanticism and English portraiture. Portraiture had a specific role then. William Hogarth in the first part of the eighteenth century created the genre of the "Moral Modern Subject." Portraiture, just after History Painting but before landscape painting, was ranked very high because, according to the academic theorists, they "improved the mind and excited noble sentiments." There was a particular value in depicting the figure in all his glory, stature, and rank. In the tradition of allegorical, mythological, biblical, and history painting, portraits were commissioned by aristocrats to portray a Lord as a Lord and a Lady as a Lady.

KW: Yes, at the time, to have your portrait painted by a famous British artist was an incredible social achievement. You were depicted as wealthy and powerful, accompanied by icons of status, worldly possessions, expensive accessories, extravagant costumes, etc.

CYK: In reaction to Neoclassicism and notions of emotional restraint, logic, order, technical precision, and form in painting, Romanticism allowed for fantasy. In portraiture, icons and signifiers of dignity, decorum, and class took precedence over accuracy. Content, and meaning through content, allowed for the creation of new mythologies and fantasies. I have noticed that kind of navigation of language and content in your work.

KW: Conceptually, they both do the same thing. Neoclassical and Romantic painting were both about manipulating reality. I think that was the fantasy and escapism that was so fascinating to me as a child. And then being a young black kid in LA, there a was another level of removal which also served as a point of re-entry. So it went from there to later on having a mentor, an artist whose specific interest in painting was something that I wasn't particularly interested in at all: French

Rococo. Fragonard particularly, and that was high school really; I spent a lot of time in high school looking at Fragonard in art history books.

CYK: Where did you go to high school?

KW: Los Angeles County High School for the Arts, a small specialized school à la *Fame*. My mentor was an excellent painter, but he had a very conservative view on art.

CYK: What was his view?

KW: Everything for him was figurative realism.

CYK: What was his approach to representation of the body?

KW: There was a lot of fetishization, and a kind of magical naturalism. He was a white man painting black subjects.

CYK: And making black bodies appear "beautiful"…? To whom and for whom?

KW: It was beauty. They were beautiful paintings, but it wasn't empowering. It was just on the surface of the canvas. He would create copies of Rubens, copies of Fragonards, and insert black bodies into these paintings. He still makes art today for the portrait, poster market.

CYK: So it was a commercial practice?

KW: Right, it was commercial.

CYK: Was he a "good" painter?

KW: He was an excellent painter.

CYK: Why was he painting black figures?

KW: Because there is this huge market for this type of material.

CYK: Was that problematic for you?

KW: No, not at the time. I really just admired the work, and I admired his skills and craftsmanship. Only later did I think, wow, here you have this man of Lebanese and French ancestry in California painting African Americans. Ironically, it's from him that I learned how to mix colors and manipulate paint for black skin and bodies. It was a very bizarre thing. And so that was in a way part of my training. I see now how I critique and

embrace the same traditions, like sibling histories. I like to think of history as a rhetorical device.

CYK: It's a dual process, divorcing narratives from context while also hybridizing periods and methodologies.

KW: Yeah, like my mentor's practice on one hand and Yinka Shonibare's very conscious irony and play on the other. I started thinking about these dualities when I entered undergraduate school at the San Francisco Art Institute. It was there that I started to think about creating my own voice, and I went out to make a bunch of Odd Nerdrum paintings with black bodies inserted and it was my sort of "Neo Negro Nerdrum" phase. These are basically a bunch of paintings that are horrifically dark.

CYK: Literally and metaphorically.

KW: Precisely. The entire point was to have a sort of yearning gravitas to it. I was also thinking about myself as the painter and the black body, or perhaps me, again, as the subject and the object, or representing something or someone else or African Americans in general. It's layered because of the colonialist history through which one perceives one's own identity, kind of like the way Du Bois discusses double consciousness.

CYK: And that is part of the simultaneous embracing and critiquing?

KW: Exactly. When I arrived in San Francisco, I still had a very conservative or sentimental view of painting. I believed painting could communicate not only the feelings of the artist, but the person that the artist is portraying. I believed that in this work he was creating a world that could not only be read or understood, but felt. There was a certain allegiance to that.

CYK: Those paintings from the mid-'90s are very moody and full of loaded imagery.

KW: Oh, those feel so old. I was introducing a conversation about blackness. I was looking at a lot of Betye Saar's work at

49

the time, and thinking it was "meaningful" black art, and to some extent I still believe it is. I felt it was really important to look at a negative history head on and to integrate it literally. At that time I was also thinking about the onion as a metaphor for complexity. I was thinking about how on the one hand I wanted to use this watermelon as black pain, as the weight of representation, you know, the Reconstruction-era stereotype that Negroes like fruit, Negroes like warm climate, Negroes like trees, ripe fruit, watermelon... I didn't necessarily feel that this was the best material to use but I hadn't anything else to use. I felt like I had no choice but to use the watermelon because there was this expectation that I was going to make my big Negro statement. I was experimenting. At the San Francisco Art Institute it felt that all of the other students were freer to choose their art practice, content, and form, and simply recreate versions of conceptual minimalism, abstract expressionism, etc. I always felt directly or indirectly encouraged to make work that referenced a negative history and that critically evaluated black history in America as it related to any number of atrocities. It sounds like I am complaining about this, but in the end, it took me through a concourse where I had to develop something on my own thing, related and unrelated to expectations, European art history, colonialism, modernism, representation, identity. Something had to come out of the discussion of blackness as a presupposed project. I had to look deeper and wider for my own heroes and processes of negotiation.

CYK: You have a curiously motley crew of influences and contemporaries.

KW: Oh yeah. From my high school art teacher to Betye Saar, Kerry James Marshall, Vanessa Beecroft, Glenn Ligon, Su-en Wong, Lisa Yuskavage, John Currin, Gerhard Richter. I love how Yuskavage and Currin dip into period portraiture and add grapefruit breasts, bug-eyes, ridiculous hourglass figures, and provocative gazes to Piero della Francesca hair, angelic skin, pre-pubescent girls in their underpants... Currin especially with his combinations and contradictions. I think Michael Kimmelman once noted in a review the combination of Cranach, Calvin Klein ads, and Vargas pinups.

CYK: Dosso Dossi...

KW: Titian and Giorgione...

CYK: Rubens...

KW: Flea market girly prints from the 1970s.

CYK: What about Kerry James Marshall—the allegory of the American Negro?

KW: Yes, his use of period style as a tool. His figure in space comes from a language of painting derived from public work with political content. I am interested in beauty as a tool of and for revolution, as in the case of the Mexican Muralists, especially Rivera.

CYK: Are you interested in moralism?

KW: Yes, but it's tricky. I am interested in Volosinov, the Russian Marxist from the early 1900s who discussed language as social. These types of ideas allow for the production of meaning to be related to unequal power relationships in social life. Thus you have a sense of class struggle at the level of sign. I began to approach a moral center itself at the level of sign. This made the imperative of morality open to critique. There's always room for subversive intent, but this I realized more recently. After San Francisco I went to Yale University for my MFA. One of the things that I always strive to do in my work is to recognize the disconnect between the object of blackness and myself. There I was subjected to people telling me that my paintings were too obvious. My references to blackness were too direct and they wanted something a little more personal. The crisis for me was how to create a personal statement, what is a personal statement about who anyone is, and is art ever capable of acting as a vehicle for that sort of endeavor. I came up with a few answers, and I still haven't answered a lot of

them. But some of the answers that I found for myself were that as opposed to trying to create, I'm still concerned with figuration here and ultimately with infiguration. I consider this to be some form of portraiture. The black body represented, to some extent, is my own black body. I took a stance where the lines between artist as fantasizer and blackness as fantastic become blurred.

CYK: At Yale, how did you respond to Harold Bloom's discussion of history as a sort of stage for art practice and perhaps the artist's relation to heroes? Whose history would that become?

KW: It felt limiting because I wanted to critique Eurocentricism in art history. Many of my heroes take on class and misogyny in their work but rarely race and cultural allegiance. John Currin, for example, uses technique almost as a signifier of the power of western easel painting…as a vehicle of representation. One of the things I admire about his work is the way that he was capable of at once using the language of painting as a rhetorical strategy and inserting his own, what you might call, perversions, into the picture. The two languages coexist and what you end up with is this third object. But in relation to Bloom, yes, Currin is allowed to do that because it is Currin's history. I never wanted to be white but that indisputable access to the history of western painting becomes sickly desirable.

CYK: I find that you have developed a methodology, perhaps of combinations and contradictions, of style and iconography, that recognizes yet transcends those limitations.

KW: With the work that I'm doing now, I am interested in history as it relates to "bling bling." (He laughs.) In places like Harlem, people ornament their bodies, love Gucci, and Versace, baggy jeans, bubble jackets, hoodies… I'm interested in architectural ornament, certain types of French Rococo facade ornaments for instance that end up as faux décor in shopping malls or Michael Graves faux neo-classicism Pomo

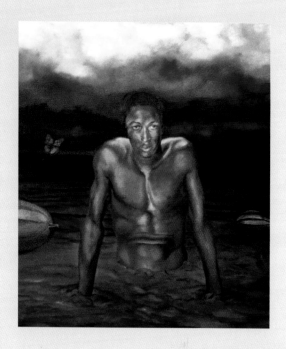

KEHINDE WILEY
Untitled, 1998

51

for that matter.

CYK: And integrating this ornamentation and décor with eighteenth-century portraiture? What other kinds of elements are you bringing into the picture?

KW: Well, hair as ornament. Hair is not only ornament, but also ornament as a statement about cultural desire—straight hair, phallic hair, labor-intensive hairstyles, black-is-beautiful afros, so many things.

CYK: And color as well. You literally use Martha Stewart paints and so-called preppy color swatches, don't you?

KW: Yes. Color is social. And when I was thinking about class and what types of pairings I would make with, say the type of suit the business man depicted in [my painting] *Conspicuous Fraud #1 (Eminence)* was wearing, I was thinking about creating interesting combinations of texts really. Martha Stewart created a line of towels, cups, and domestic items for Kmart, in 1999, I think. It was all a sort of hospital-green/sea-foam-green color. It was an interesting swatch selection; I wasn't sure if it would come across to the viewer, but I wanted to create a tension between a black male body, which is traditionally not aligned with this sort of puritanical aesthetic, and of course I wanted to have something that was a high-affect coloration, like the bright orange tie that he's wearing. To me the confluence of those two creates a ridiculous sensation that addresses the desire for acceptability. It's also pointing at how acceptable these seemingly disparate things are really, because in the paintings these things seem to jibe really well.

CYK: It's almost as if you are creating a diorama, setting up a picture, selecting and placing consciously incongruent or culturally loaded objects and elements, and then documenting them as stills.

KW: Yes, in this way I align myself with photographers like Anthony Goicolea. He is composing a diorama, a portrait of ridiculous adolescent sexual, social, and behavioral decadence.

He is able to discuss desire and fetishization, subjectivity and objectivity, representation and portraiture. I like the humor and, again, this duality of embracing and critiquing socialized presumption.

CYK: When one translates that to painting, the reading changes.

KW: It can get even more interesting. Look at Delia Brown.

CYK: Ah-ha, yes. Did you see her last solo exhibition at Margo Leavin Gallery in Los Angeles?

KW: I heard about it.

CYK: She exhibited a series of paintings and drawings representing a constructed relationship between Margo and herself, as mother and daughter. They are based on staged photographs: the two of them in the kitchen, mother is cutting the vegetables, daughter is cooking; by the pool, the daughter in a bikini, the mother is in a caftan; in the garden, the daughter holding the basket, while the mother is clipping the rose bushes; in the living room portrait, the daughter sitting on the arm of the armchair, and the mother is in the chair with the fake Baldassari behind them. They are beautiful large-scale portraits. They are fake and they are real. They are dioramas. And they are paintings.

KW: Her work is very strong, and it's important that we see these as paintings and drawings. Now when it comes to photographic space, there is an assumption that the photographic space is portraying real space and real time, that it has an indexical relation to actuality, and then in work of artists like Gursky, who intervene digitally for instance, reality and time are questioned, and he is also working like a painter. In my own work, history is questioned. Would this ornament belong to something like say a Versace jacket or is it really Baroque? So the question of appropriation comes into play. Period style is treated as something kitsch as opposed to something immediate and tangible. It's held at an arm's length. History becomes

a plaything. I create something akin to the diorama in that the figure is situated in a contrived, constructed space, but I'm also borrowing from images from, say, the ascension Christ and placing black bodies there. The whole purpose of this project is to manufacture a sense of eminent visibility, to brutalize the language of imminent visibility, and to draw upon its strength as a historical marker, as referent to something we all recognize intrinsically, much like when I was a youngster looking at those early English portrait paintings. I want to aestheticize masculine beauty and to be complicit within that language of oppressive power while at once critiquing it. The work I think attempts to navigate those two fields without answering any questions that might be assumed of me. I'm not particularly interested in providing answers to questions of morality, I'm more interested in creating situations...

I draw inspiration from artists who aren't necessarily painters. I remember looking at the Gursky show at the Museum of Modern Art and thinking about heroic scale, about the way that John Currin fetishizes technique as something that is specifically heroic. But also there is a certain amount of heroic intent in the work of Kerry James Marshall whose concerns include canonical insertion. I remember even as a child looking at one of his paintings in Los Angeles called *Destyle*, which the painting in *Black Romantic, Conspicuous Fraud #1 (Eminence)*, is sort of a send up to. In that painting you have a number of black men in a barber shop and they are huge. It's the scale of history painting, and it's in this space dominating this world just as much as a large Motherwell would. I construct the heroic also as a tool for talking about something that is not heroic. I use the heroic as a means of talking about the pathetic. I'm very much interested in the ways in which structures are fragile in a sense, and a lot of my work concentrates on the fault lines of structures, much in the same sense that Kurt Kauper created those nude self-portraits.

Here this white male body, presented to the world as something that may be read as powerful, is actually something rather comical and seemingly pathetic. And there is a certain amount of humor in that. I think that humor is implicit in the work that Kurt made. I definitely use humor in my own work as a means of obviating the fluidity of languages.

CYK: Heroicism, irony, romance...

KW: The two earlier paintings in *Black Romantic* go back to Nerdrum, but the same amount of romance that Nerdrum brought to his work is akin to someone like Caspar David Friedrich, whose work I was looking at as well. In both of these cases the figure in the landscape is at once vulnerable and someone who is capable of mastering the world as well, which of course gets back to Emerson, man and nature, and the ways in which one sees his own agency, the great wilderness that lies ahead, and a romantic notion of male agency. So in the show you've got examples of two very different types of paintings from two very different points in my practice. While you have something that is intentionally very romantic in its positing of the black male in the land (in one painting even the black male consumed or subsumed by the land), in the later paintings the very nature of that language turns in on itself. And its an interesting opportunity to have both of those vernaculars posited, each commenting on the other...about the practice of painting.

CYK: The vitality of painting, the practice of painting...

KW: And I think the other has to do with the usefulness of painting...

CYK: What is the function of painting today?

KW: It's a very hard thing to articulate. Much of African-American figurative painting has a specific relationship with positivism. I don't think that positivism is always interesting; and personally, if I can make moves on that question of positivism itself, then I'm doing something worthwhile. However,

the kind of positivism that exists in African-American figurative painting is about self-representation and regardless of where the language comes from, it's also about taking canons and genres and claiming and appropriating them to a positive end. So it's important and very real, and I respect that immensely. It might be criticized as unoriginal or low art, but then Sean Landers copying a Picasso is somehow an ironic observation of history that manages to maintain a very provocative, personal, poetic sensibility. Sure I'm interested in irony, but I'm also interested in sincerity and the question is how can I tie the two together.

 CYK: When I look at your work I see you tying together not just two but a multitude of seemingly disparate but actually parallel or complementary practices, languages, and notions.

 KW: Well there is a multiplicity of any number of periods, artists, ideas, any number of political and moral allegiances in my work, and that's the point. I think it's always important not to shut the work down with any sense of high-art audience versus black-people-in-the-street audience. I'm not interested in having to choose between being real and being heady. I'm trying to be true to an essence of urgency, to replicate sensations and ideas visually, to bring to the table not only my own desires but things that point to the larger evolution of culture, art, and art history.

Artists

Alonzo Adams

Born 1961, Harlem, NY
Lives and works in Plainfield, NJ

EDUCATION

1991 MFA University of Pennsylvania, Philadelphia, PA

1984 BFA Mason Gross School of the Arts, Rutgers University, New Brunswick, NJ

SELECTED SOLO EXHIBITIONS

2001 Swains Art Gallery, Plainfield, NJ

2000 La Mère L'Enfant Gallery, Houston, TX

1997 Metropolitan Art Center, Detroit, MI

1993 Blackburn Center, Howard University, Washington, DC

1987 Gallery Plus, Los Angeles, CA

SELECTED GROUP EXHIBITIONS

2001 Savacou Gallery, New York, NY

2000 National Black Arts Festival, Atlanta, GA

1997 Montclair Museum, Montclair, NJ

1996 National Arts Club, New York, NY

1993 Forbes Art Gallery, New York, NY

Sun-soaked, 2001

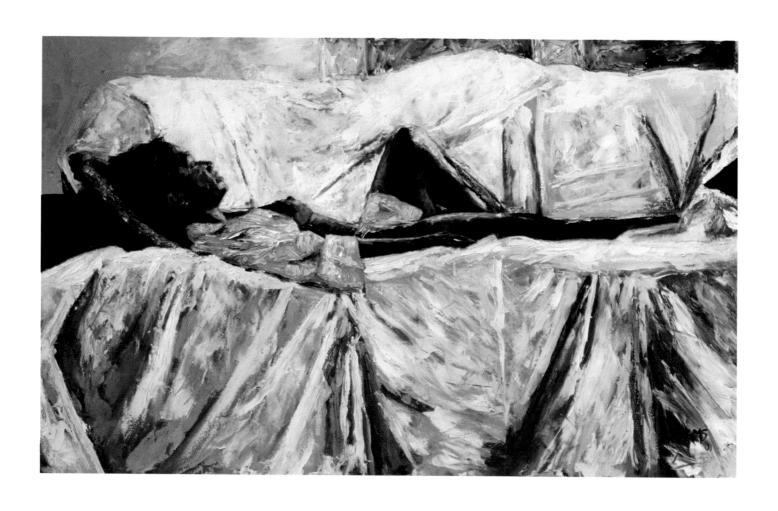

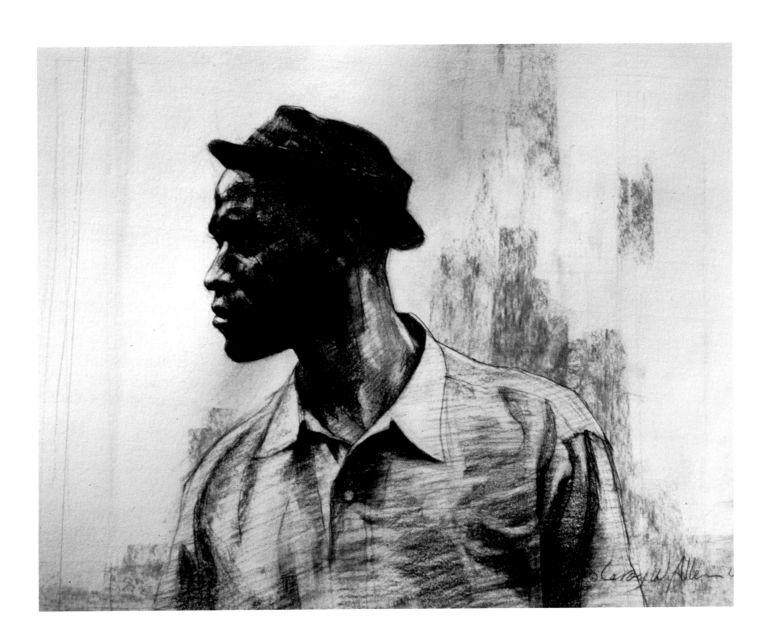

Leroy Allen

Born 1951, Kansas City, KS
Lives and works in Kansas City, KS

EDUCATION

1977 BFA School of Design, Kansas University, Lawrence, KS

1975 AA Kansas City Kansas Community College, Kansas City, KS

SELECTED SOLO EXHIBITIONS

2000 Hallmark Cards Headquarters, Kansas City, MO

1994 Kansas City Public Library, Kansas City, KS

1990 Bruce R. Watkins Cultural Center, Kansas City, MO

SELECTED GROUP EXHIBITIONS

2001 *Oklahoma Watercolor Association National Exhibition*,
Oklahoma City, OK

2000 *American Watercolor Society 133rd International Exhibition*,
New York, NY

Black Creativity, Museum of Science and Industry,
Chicago, IL

Vision 2000, Portfolio Gallery, St. Louis, MO

1999 *The Kansas City Six Reunion Exhibition*, Bruce R. Watkins
Cultural Center, Kansas City, MO

The Glance, 2001

Iana L.N. Amauba

Born 1975, Eugene, OR
Lives and works in Brooklyn, NY

EDUCATION

2001 MFA New York Academy of Art, Graduate School of
Figurative Art, New York, NY

1999 BFA The School of the Art Institute of Chicago, Chicago, IL

SELECTED GROUP EXHIBITIONS

2001 *Will's Creek Survey 2001 Exhibition*, Allegany Arts Council,
Cumberland, MD

Realism III Group Exhibition, Period Gallery, Omaha, NE

Paint the Town Red Exhibition & Auction, Rene Lezard,
New York, NY

2000 *Take Home A Nude Annual Art Exhibition & Auction*,
New York, NY

College Association of Arts' Bi-Annual Art Exhibition,
Hunter College, New York, NY

Fly in Milk II, 2001

 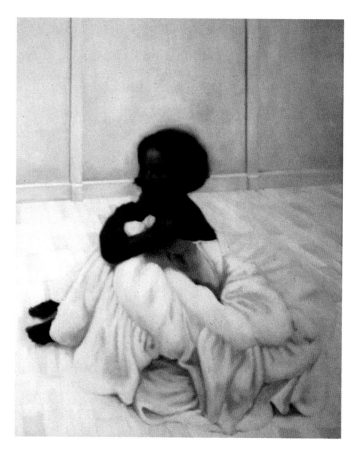

Alexander Austin

Born 1961, Tallahassee, FL
Lives and works in Kansas City, MO

EDUCATION

Self-taught

SELECTED SOLO EXHIBITIONS

1998 G.C. Mayfield Gallery, Kansas City, KS

Whispering Lake Apartments Clubhouse, Kansas City, MO

SELECTED MURAL PROJECTS

1998 *African American Read-In*, Kansas City, MO

Foundations, 18th Street b/w Euclid and Garfield,
Kansas City, MO

1997 *InterFaces Mural*, travels with InterAid International to Asia,
Africa, and Central America

Mural of Mayor Emanuel Cleaver, Kansas City, MO

Break the Chain of Violence: Educate, Mural at 58th and
Troost, Kansas, City, MO

Spirit of the Dream, 1994

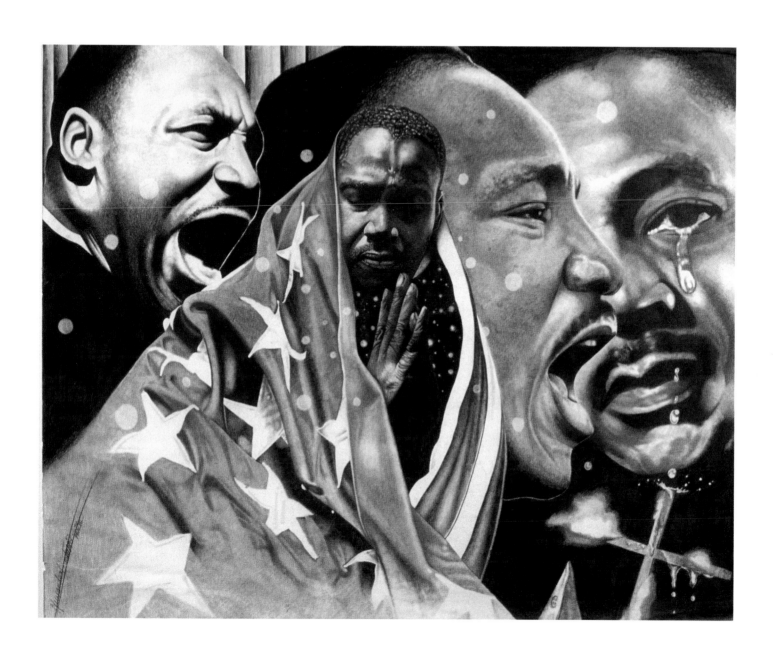

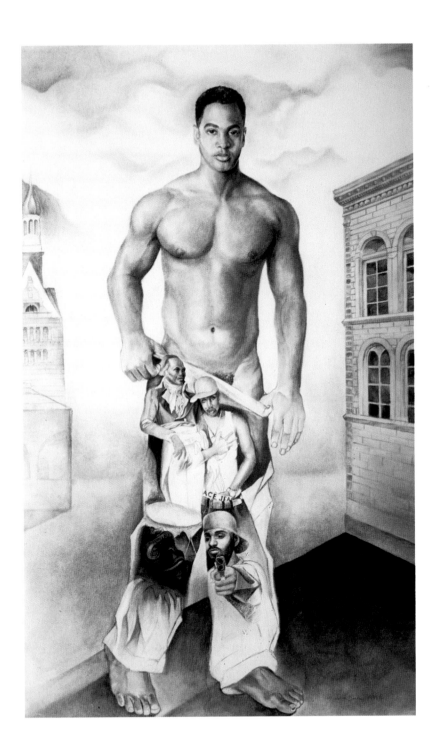

Marlon H. Banks

Born 1965, Milwaukee, WI

EDUCATION

2000 MFA University of Wisconsin, Madison, WI

1995 Teacher Certification, University of Wisconsin, Milwaukee, WI

1987 U.S. Army Computer Science School

1986 BA Carroll College, Waukesha, WI

SELECTED SOLO EXHIBITIONS

1998 Memorial High School, Madison, WI

Milwaukee Brady Clinic, Milwaukee, WI

1992 *Other Voices*, University of Wisconsin, Milwaukee, WI

SELECTED GROUP EXHIBITIONS

1991-94 *Gallery 218 Cooperative Artist Group Exhibitions*, Milwaukee, WI

William Undressing Stereotypes, 1999

Nina I. Buxenbaum

Born 1974, Brooklyn, NY
Lives and works in Brooklyn, NY

EDUCATION

2001 Skowhegan School for Painting and Sculpture,
 Skowhegan, ME

2001 MFA Maryland Institute College of Art, Hoffberger School of
 Painting, Baltimore, MD

1996-97 L'École du Louvre, Paris; L'Institut Catholique of Paris, France

1996 BFA Washington University, St. Louis, MO

SELECTED SOLO EXHIBITIONS

2001 *Black Women, Black Dolls*, Meyerhoff Gallery, Baltimore, MD

 Sylvan & Isabelle Ribakow Art Gallery, Baltimore, MD

SELECTED GROUP EXHIBITIONS

2000 *About Drawing*, Park School Gallery, Baltimore, MD

 Pre-College Program Faculty/Staff Group Exhibition,
 Maryland Institute College of Art, Baltimore, MD

 Hoffberger Group, Maryland Institute College of Art,
 Baltimore, MD

1999 *Hoffberger Group*, Maryland Institute College of Art,
 Baltimore, MD

1995 Hatshesput Gallery, St. Louis, MO

The Annunciation, 2000

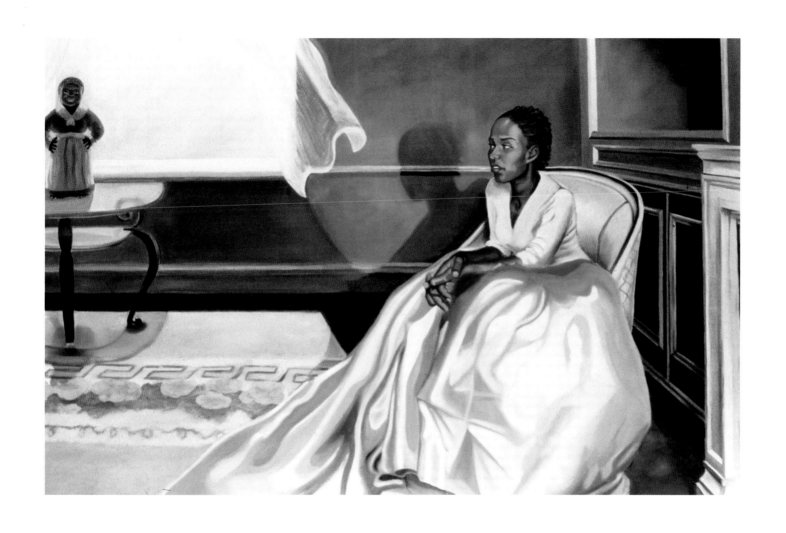

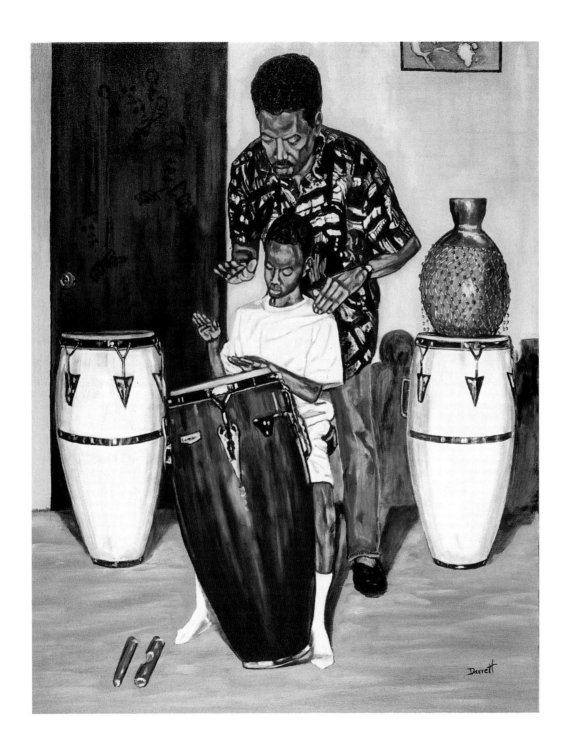

Clifford Darrett

Born 1941, Evansville, IN

Lives and works in Dayton, OH

EDUCATION

1979 MS University of Dayton, Dayton, OH

1974 BS Central State University, Wilberforce, OH

1973 AA Sinclair Community College, Dayton, OH

SELECTED SOLO EXHIBITIONS

1999 *The Art of Clifford Darrett*, Miami Valley Cooperative Gallery, Dayton, OH

Clifford Darrett: Recent Paintings, Evansville Museum of Arts and Science, Evansville, IN

1998 Montgomery County Board of Elections, Dayton, OH

1995 *The Art of Clifford Darrett*, Miami Valley Cooperative Gallery, Dayton, OH

SELECTED GROUP EXHIBITIONS

2000 *Art About Town*, Old Courthouse Museum, Dayton, OH

African-American Invitational Art Exhibition, Actors Theatre of Louisville, Louisville, KY

Roots of Diversity, One Seagate Gallery, Toledo, OH

1999 *Indiana Black Exposition; The Best*, Indianapolis Convention Center, Indianapolis, IN

1998 *Innervisions: Individuality and Creativity Among Ohio Artists of African Descent*, National Afro-American Museum and Cultural Center, Wilberforce, OH

The Drum Lesson, 1999

Keith J. Duncan

Born 1964, New Orleans, LA
Lives and works in New York, NY

EDUCATION

1994 MFA Hunter College, CUNY, New York, NY

1990 Skowhegan School of Painting and Sculpture,
Skowhegan, ME

1989 BFA Louisiana State University, Baton Rouge, LA

1986 Delgado Community College, New Orleans, LA

SELECTED SOLO EXHIBITIONS

1999 Gallery X, New York, NY

1998 Danny Simmons' Corridor Gallery, Brooklyn, NY

1996 Independent Arts Gallery, Jamaica, Queens, NY

1995 GalleryOnetwentyeight, New York, NY

El Taller Boricua Gallery, New York, NY

SELECTED GROUP EXHIBITIONS

2001 Jay Grimm, New York, NY

Rush Arts Gallery, New York, NY

2000 Longwood Arts Gallery, Bronx, NY

The Gallery at the American Bible Society,
New York, NY

1999 *Under Dybbolsbro: Kulturfabrikken*, Copenhagen,
Denmark

The Conversion of Saul II, 2001

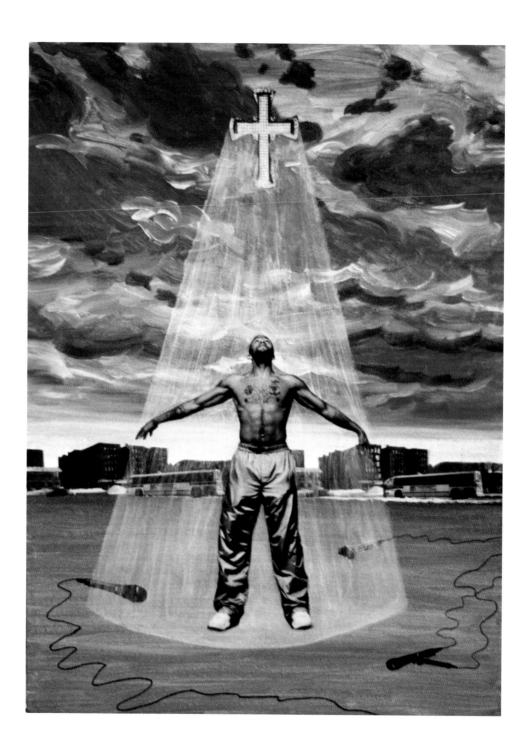

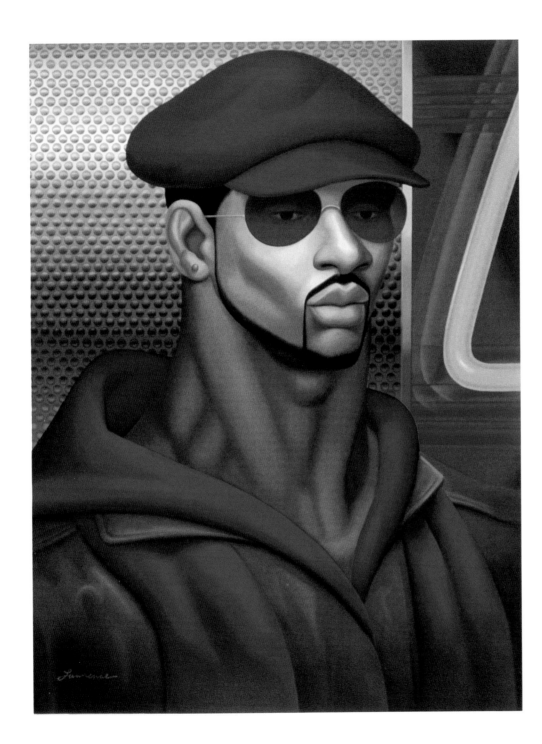

74

Lawrence Finney

Born 1963, Brooklyn, NY
Lives and works in New York, NY

EDUCATION

1985 School of Visual Arts, New York, NY

1982-84 Pratt Institute, Brooklyn, NY

SELECTED SOLO EXHIBITIONS

2002 Fairleigh Dickinson University, Teaneck, NJ

2001 *City Girls/City Boys*, UFA Gallery, New York, NY

 Dreams, Visions, Statements, Hearne Fine Art,
 Little Rock, AR

2000 *Subjective Male*, UFA Gallery, New York, NY

 Drawing and Watercolors, Simone's Gallery, Pelham, NY

SELECTED GROUP EXHIBITIONS

2002 *Believe*, Fairleigh Dickinson University, Teaneck, NJ

2000 Iandor Fine Arts, Newark, NJ

1999-2001 *Annual National Black Fine Art Show*, New York, NY

1999 *Faces of America II*, Nabisco, East Hanover, NJ

City Boy, Red Scarf, 2001

Gerald Griffin

Born 1964, Chicago, IL
Lives and works in Chicago, IL

EDUCATION

1986 BFA The School of the Art Institute of Chicago, Chicago, IL

SELECTED SOLO EXHIBITIONS

2001 *Future Shock*, Griffin Graphics, Inc. Gallery, Chicago, IL
 Spiritual Journey, Griffin Graphics, Inc. Gallery, Chicago, IL

1999 *Retrospective*, Builders Bank, Chicago, IL
 Distant Memories, Griffin Graphics, Inc. Gallery, Chicago, IL
 Retrospective '99, Malcolm X College, Chicago, IL

SELECTED GROUP EXHIBITIONS

2001 *Chicago Renaissance*, Chicago State University, Chicago, IL
1999-2002 *Annual National Black Fine Art Show*, New York, NY
1998-99 *Black Creativity Annual*, Museum of Science and Industry, Chicago, IL
1997 *National Black Fine Art Show*, New York, NY
1996 *Expressions from the Black Experience*, DuSable Museum of African-American History, Chicago, IL

Human Nature, 2000

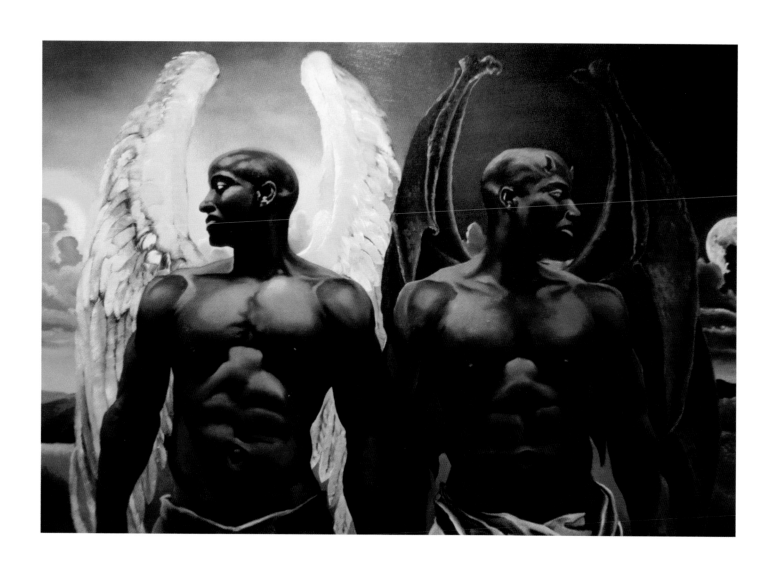

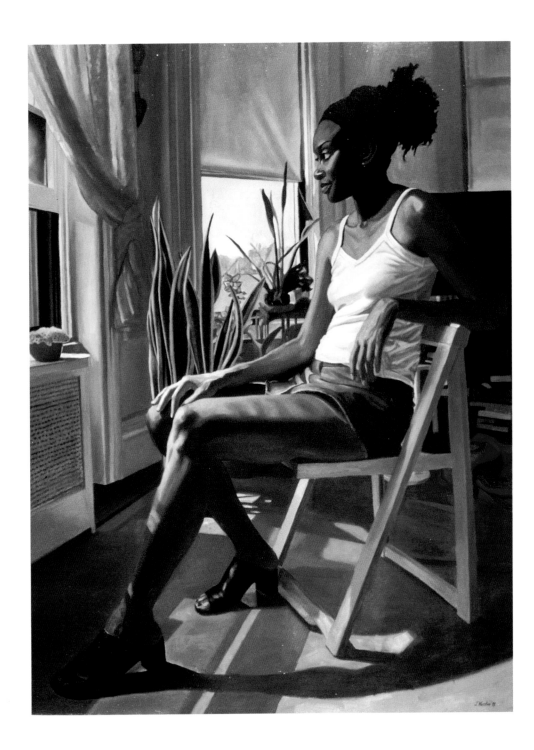

James Hoston

Born 1963, Freeport, NY
Lives and works in Brooklyn, NY and Boston, MA

EDUCATION

1991 MFA The Graduate School of Figurative Art, New York
Academy of Art, New York, NY

1986 BFA Pratt Institute, Brooklyn, NY

1983 AAS SUNY Farmingdale, Long Island, NY

SELECTED TWO PERSON EXHIBITION

2000 Rock Art Foundation Gallery, Valdese, NC

SELECTED GROUP EXHIBITIONS

2001 *Whatever it takes*, Pennsylvania School of Art and Design,
Philadelphia, PA

2000 *Our Own Show*, Society of Illustrators Gallery, New York, NY

A Visual Journey of the African American Spirit, FireHouse Art
Gallery, Garden City, NY

New York Classicism Now, Hirschl & Adler Modern,
New York, NY

1997 *Legends, The Group Exhibition Continues*, Bill Hodges,
New York, NY

79

Hot Day In, 1998

Robert L. Jefferson

Born 1929, Philadelphia, PA
Lives and works in Yeadon, PA

EDUCATION

1955 Certificate, L'Académie de la Grande Chaumière,
 Paris, France

1951 Philadelphia Museum College of Art—Diploma in Illustration
 and Decoration

SELECTED SOLO EXHIBITIONS

1998 Monday's Child Art Gallery, Norristown, PA

1991 Gloucester County College, Sewell, NJ

1982 Gloucester County College, Sewell, NJ

1962 Art Alliance, Philadelphia, PA

SELECTED GROUP EXHIBITIONS

1995-2001 *Annual October Gallery Art Expos*, Philadelphia, PA

1996-98 *Annual National Black Arts Festival*, Atlanta, GA

1997 Art Buyers Caravan, Atlanta, GA

1996 Dizyner's Gallery, Philadephia, PA

Seek... the Light, 1999

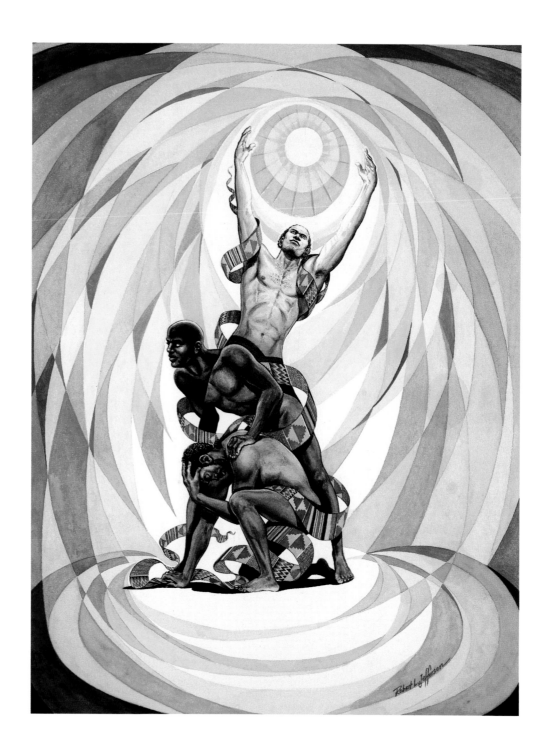

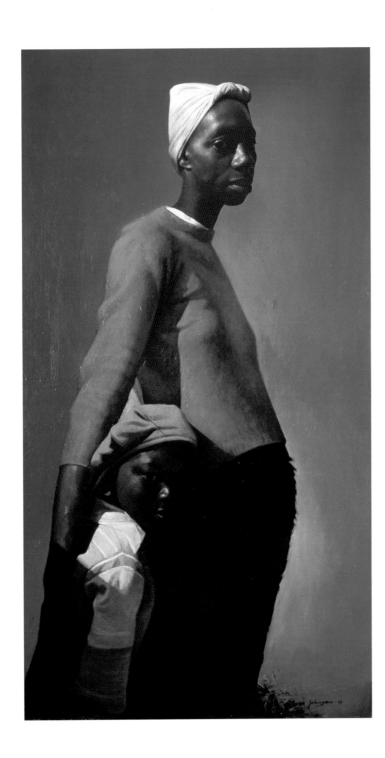

Oliver B. Johnson, Jr.

Born 1948, Jacksonville, FL
Lives and works in Stroudsburg, PA

EDUCATION

Self-taught

SELECTED SOLO EXHIBITIONS

1998 Madeline Powers Gallery, East Stroudsburg University, PA

1996 Bixler Gallery, Stroudsburg, PA

1987 Cigna Corporation, Philadelphia, PA

1979-87 Galerie Felicie, New York, NY

1979 Wildenstein Company, New York, NY

SELECTED GROUP EXHIBITIONS

1995 Charles Graham Gallery, New York, NY

1993 Blue Hill Gallery, Nyack, NY

1984 Wally Findlay Gallery, New York, NY

1977 Skylight Gallery, Bedford-Stuyvesant Restoration Corporation, Brooklyn, NY

Madonna and Child, 1995

Troy L. Johnson

Born 1968, Philadelphia, PA
Lives and works in Culver City, CA

EDUCATION

1996 MFA Howard University, Washington, DC

1992 BA Carnegie-Mellon University, Pittsburgh, PA

SELECTED SOLO EXHIBITION

2001 Expressions, Ladera Heights, CA

SELECTED GROUP EXHIBITIONS

1999-2001 *Annual Unified Art Show*, Strathmore Gallery, Bethesda, MD

1998-99 Martin Luther King Memorial Library, Washington, DC

1994-96 *Annual Congressional Black Caucus Convention*,
Washington, DC

SELECTED MURAL PROJECTS

1996 Howard University Law School, Washington, DC

1995 Subway Station, Metro Mural at U Street Cardozo Station,
NW, Washington, DC

Third District Police Station, V Street, Washington, DC

Quilting the Fabrics of Life, 1994

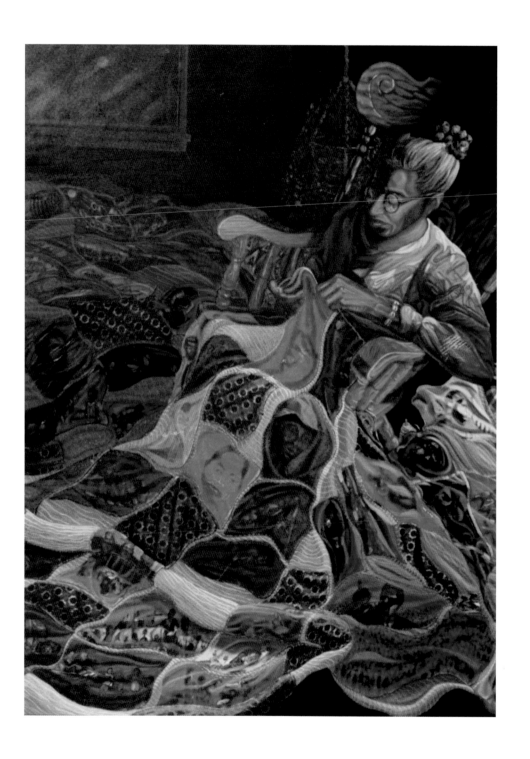

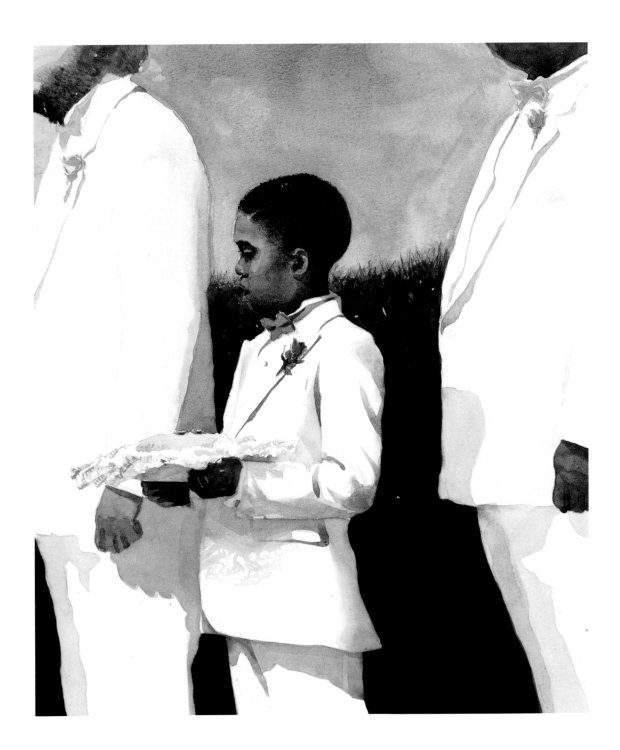

Jonathan Knight

Born 1959, Daytona Beach, FL
Lives and works in Shawnee, KS

EDUCATION

1979 BFA Art Institute of Fort Lauderdale, FL

SELECTED SOLO EXHIBITIONS

1999 Bethune-Cookman College, Daytona Beach, FL

1998 Governor's Club, West Palm Beach, FL

1997 Ormond Memorial Art Museum and Gardens,
Ormond Beach, FL

1996 Cornell Museum, Delray, FL

The Armory Art Center, West Palm Beach, FL

SELECTED GROUP EXHIBITIONS

2001 Joysmith Gallery, Memphis TN

1998 *Southern Watercolor Society 21st Annual Juried Exhibition*,
Talledega, FL

Fifth Annual Miniature Art Show, Casper, WY

San Diego Watercolor Society International Exhibition,
San Diego, CA

1996 *Fifty-Fourth Audubon Artists Exhibition*, New York, NY

Ring Bearer, 1994

Jeanette Madden

Born 1950, Berkeley, CA
Lives and works in Oakland, CA

EDUCATION

1976-77 California State University, Hayward

SELECTED SOLO EXHIBITIONS

2001 *Annual Black History Month Featured Artist*, East Bay
Municipal Utility District, Oakland, CA

SELECTED GROUP EXHIBITIONS

2002 *Dark Mother: African Origins and Godmothers*, California
Institute for Integral Studies, San Francisco, CA

The Art of Living Black Exhibition and Tour, Richmond Art
Center, Richmond, CA

I am Black History in the Making, Borders Books, Pleasant
Hill, CA

Crossing Bridges featuring the Art of Living Black,
CBS MarketWatch.com, San Francisco, CA

2001 *Equilateral, the Works of Three Women*, San Pablo Gallery,
San Pablo, CA

Woman with Flowers, 1987

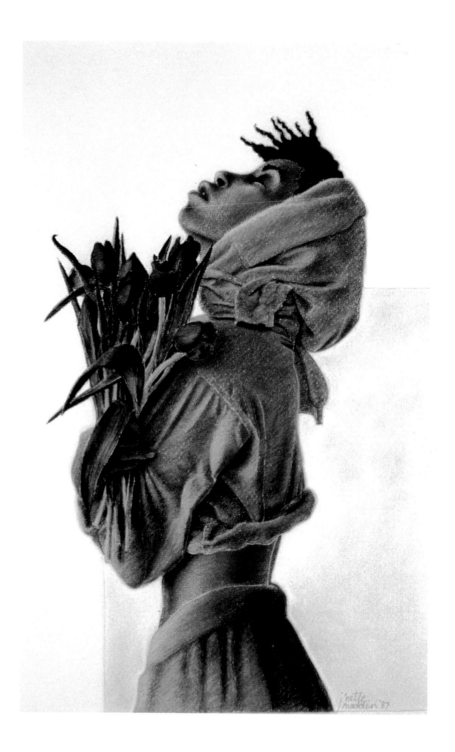

89

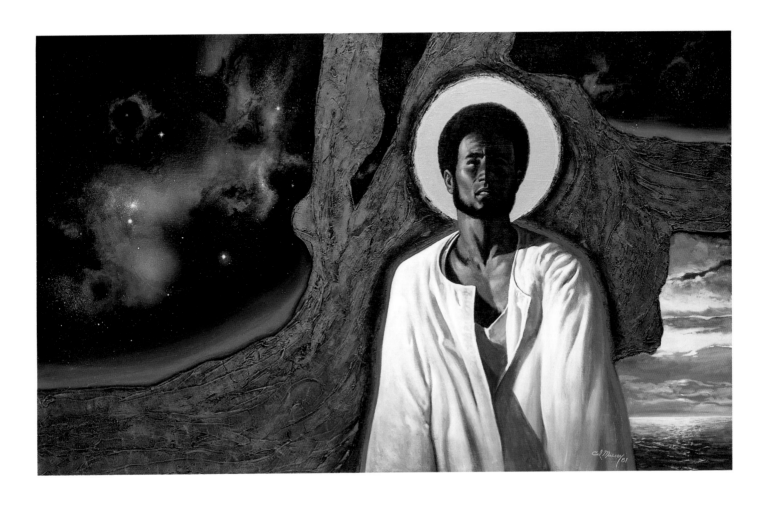

Cal Massey

Born 1926, Darby, PA
Lives and works in Darby, PA

EDUCATION

1950 BA Hussian School, Philadelphia, PA

SELECTED SOLO EXHIBITIONS

1997 *October Gallery Art Expo*, Philadelphia, PA

1993 *Heritage Celebration*, New York, NY

1992 Gloucester County College, Sewell, NJ

1992 *Prestige Fine Arts Show*, Silver Spring, MD

SELECTED GROUP EXHIBITIONS

1998 *National Black Arts Festival*, Atlanta, GA

1997-98 *Baltimore Black Heritage Festival*, Baltimore, MD

1994-98 *Annual Philadelphia Art Expo*, Philadelphia, PA

The Messiah, 1982

Dean Mitchell

Born 1957, Pittsburgh, PA
Lives and works in Overland Park, KS

EDUCATION

1980 BFA Columbus College of Art and Design, Columbus, OH

SELECTED SOLO EXHIBITIONS

2001 Gadsen Art Center, Quincy, FL

2000 Bryant Galleries of New Orleans, New Orleans, LA

 Lyme Gallery of Fine Arts, Old Lyme, CT

1999 Central Exchange Gallery, Kansas City, MO

 Strecker Gallery, Manhattan, KS

SELECTED GROUP EXHIBITIONS

2002 *Random Acts of Beauty*, Foothills Art Center, Golden, CO

 Masters of the American West, Autry Museum of Western
 Heritage, Los Angeles, CA

1999 *Interpreting Surrounding Exhibit*, Parkland College,
 Champaign, IL

 Dean Mitchell and Others: Portraits of Human Nature,
 Cultural Arts Council of Estes Park, CO

1996-99 *Annual Great American Artist Exhibition*, Cincinnati Museum
 Center, Cincinnati, OH

Laid Back, 2001

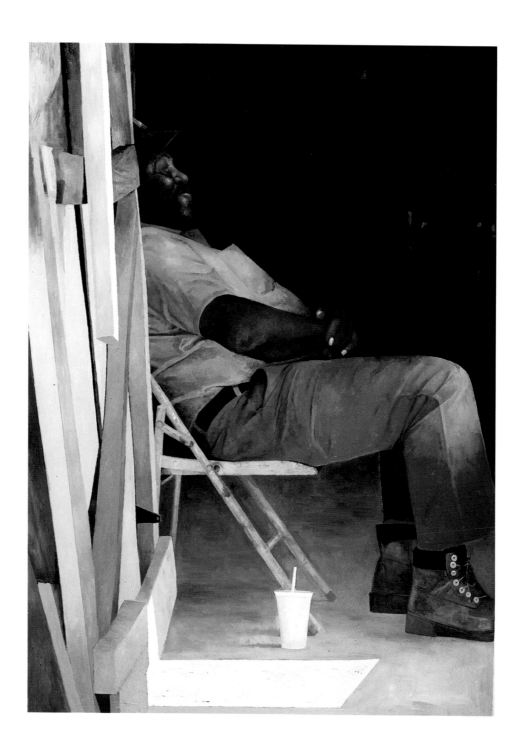

93

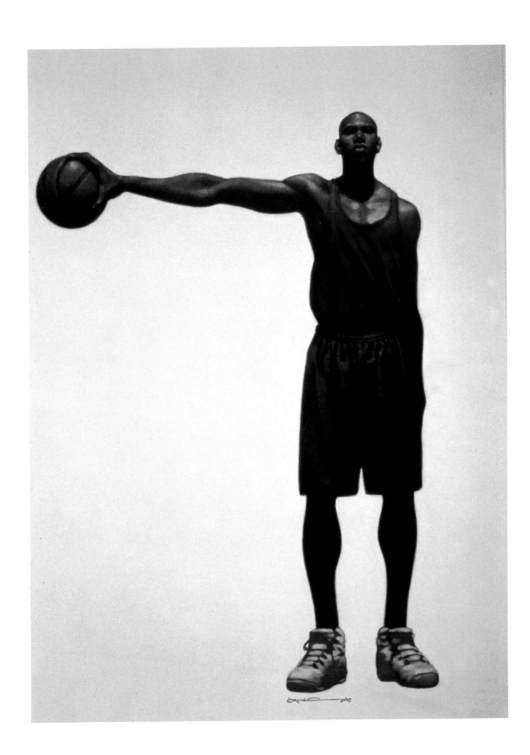

Kadir Nelson

Born 1974, Washington, DC
Lives and works in San Diego, CA

EDUCATION

1996 BFA Pratt Institute, Brooklyn, NY

SELECTED SOLO EXHIBITIONS

1999 *The Amistad Experience*, The Hayti Heritage Center, Durham, NC

1998 The Academy of Motion Pictures and Sciences Film Premiere Reception for *Amistad*, Los Angeles, CA

1992 *Black History Month Exhibit*, Atlantic City Links, Inc. Atlantic City Library, Atlantic City, NJ

SELECTED GROUP EXHIBITIONS

2002 *Painting the Dream*, Every Picture Tells a Story Gallery, Los Angeles, CA

2001 *Every Picture Tells a Story* children's book exhibit, Simon Weisenthal Center, Museum of Tolerance, Los Angeles, CA

2000 *The Art of Sport Exhibit*, San Diego Hall of Champions Sports Museum, San Diego, CA

1999 *North Carolina Central University Foundation Third Annual Gala*, Durham, NC

1997 *Cowboys, Reconstructing an American Myth*, The African-American Museum of Fine Arts, San Diego, CA

95

Right Wing, 1999

Leslie Printis

Born 1947, Philadelphia, PA
Lives and works in San Francisco, CA

EDUCATION

1979 BA Pratt Institute, Brooklyn, NY

SELECTED SOLO EXHIBITIONS

2001 *Looking In and Out of Windows*, Government Center Art
Gallery, Redwood City, CA

2000 *Images in Color*, Government Center Art Gallery,
Redwood City, CA

1998 *Colors in Paint*, San Mateo County Art Council,
San Mateo, CA

SELECTED GROUP EXHIBITIONS

2001-02 *Black Artists...Creations Annual*, San Francisco African
American Historical & Cultural Society Gallery, Ft. Mason,
San Francisco, CA

2000 *Silicon Valley Open Studios*, Foster City

ArtSpan Open Studios, San Francisco, CA

Bay Art/The Melting Pot, San Mateo County Arts Council,
San Mateo, CA

1999 Powell Street Gallery, San Francisco, CA

After the Party, 2001

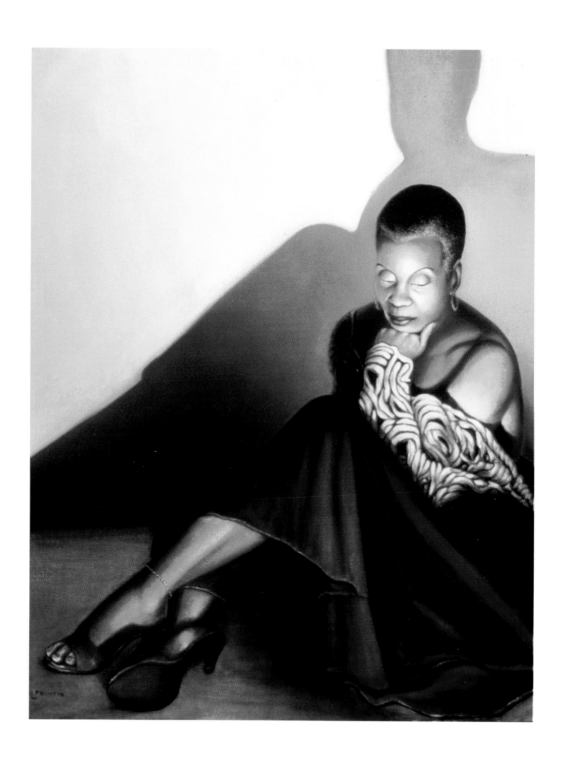

97

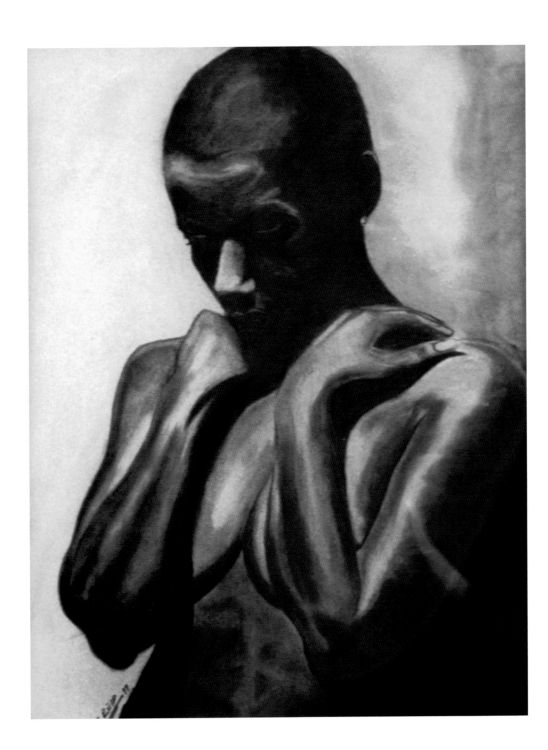

Robert V. Reid

Born 1960, Trinidad, West Indies
Lives and works in Brooklyn, NY

EDUCATION

1993 Certificate Fine Arts, Arts Students League, New York, NY

SELECTED SOLO EXHIBITIONS

1999 *Life Dance*, New Century Artist Gallery, New York, NY

1995 *Moods & Movements II*, Art Creators, Trinidad, West Indies

1993 Moods & Movements, Savacou Gallery, New York, NY

SELECTED GROUP EXHIBITIONS

2001 *Caribbean View*, Municipal Building, New York, NY

 National Black Fine Art Show, New York, NY

1997-99 *Annual National Black Fine Art Show*, New York, NY

1997 *Twenty-Sixth Annual Contemporary Black Artists in America*,
 New York, NY

The Essence of Love, 2000

Jonathon Romain

Born 1966, Chicago, IL
Lives and works in Oak Park, IL

EDUCATION

Self-taught

SELECTED SOLO EXHIBITIONS

2002 African-American Outreach Ministries, Chicago, IL

Delta Sigma Theta Alumni Association Chapter,
Cincinnati, OH

2000 Cook County Bar Association, Chicago, IL

Rose of Sharon, Chicago, IL

University of Illinois at Chicago, Chicago, IL

SELECTED GROUP EXHIBITIONS

2001-02 *Annual National Black Fine Art Show*, New York, NY

Black Creativity, Museum of Science and Industry,
Chicago, IL

2000 Anne Lee Gallery, Chicago, IL

COLORS: National Black Fine Art Exposition, Chicago, IL

Still Waters, 2001

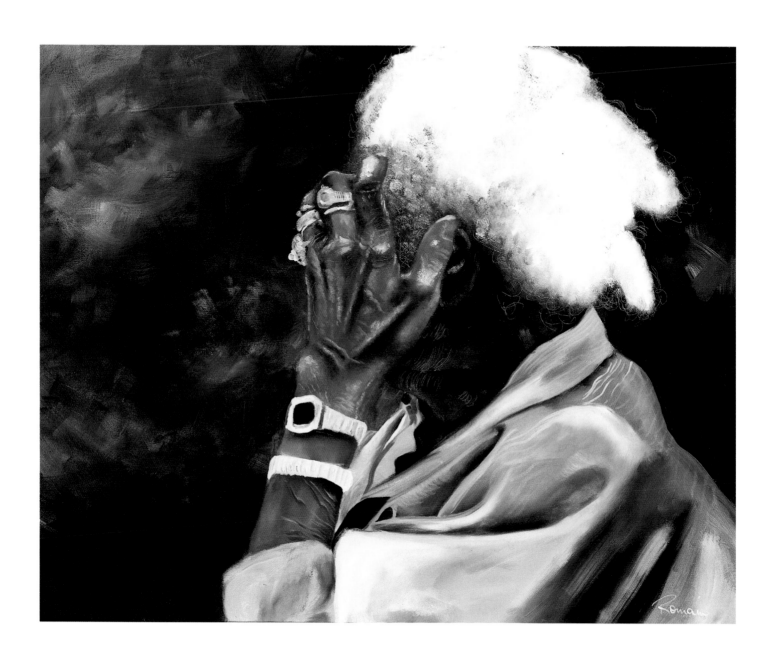

Philip Smallwood

Born 1957, New Brunswick, NJ

Lives and works in New Milford, NJ

EDUCATION

2001 The Greenville County Museum, The Museum School, Greenville, SC

1995 Arts Center of Northern New Jersey, New Milford, NJ

1989 BS University of Miami, Coral Gables, FL

SELECTED SOLO EXHIBITIONS

2000 *Lifescapes*, New Milford, NJ

1998 *Shades of Summer*, West Palm Beach, FL

1997 New York Theological Seminary, New York, NY

The Governor's Club, West Palm Beach, FL

SELECTED GROUP EXHIBITIONS

2000 *New Jersey Watercolor Society*, Monmouth County Museum, Monmouth, NJ

Coconut Grove Arts Festival, Bank of America, Coconut Grove, FL

Renewal and Regeneration, Museum of Our National Heritage, Lexington, MA

Thirty-Seventh Annual Plainfield Festival of Art, Plainfield, NJ

1999 *Thirty-Sixth Juried Exhibition*, The Parrish Museum, Southampton, NY

Another Morning I Rise, 1998

Aj Smith

Born 1952, Jonestown, MS
Lives and works in Little Rock, AR

EDUCATION

1977 MFA Queens College, CUNY, Queens, NY

1974 BFA Kansas City Art Institute, Kansas City, MO

1973 Skowhegan School of Painting and Sculpture,
 Skowhegan, ME

SELECTED SOLO EXHIBITIONS

2002 *Basic Drawing-Connections*, Arkansas Historic Museum,
 Little Rock, AR

2001 *Family Portrait*, University of Arkansas at Pine Bluff,
 Pine Bluff, AR

2000 *Aj Smith and Marjorie Williams-Smith Invitational*, Arkansas
 River Valley Arts Center, Little Rock, AR

1999 *Aj Smith/Kevin Cole*, Mary Pauline Gallery, Augusta, GA

1997 *Made in America*, Valdosta State University, Valdosta, GA

SELECTED GROUP EXHIBITIONS

2002 Little Rock Convention Center and Visitor's Bureau,
 Little Rock, AR

 Body and Soul, The Arts and Sciences Center, Pine Bluff, AR

 Making and Impression: Print Techniques in the 20th Century,
 Arkansas Arts Center, Little Rock, AR

2001 *About Face: Collection of Jackye and Curtis Finch, Jr.*, Arkansas
 Arts Center, Little Rock, AR

2000 *African-American Artists: Arkansas Arts Center Foundation
 Collection*, Carnegie Hall Museum, Lewisburg, WV

Marjorie, 1997

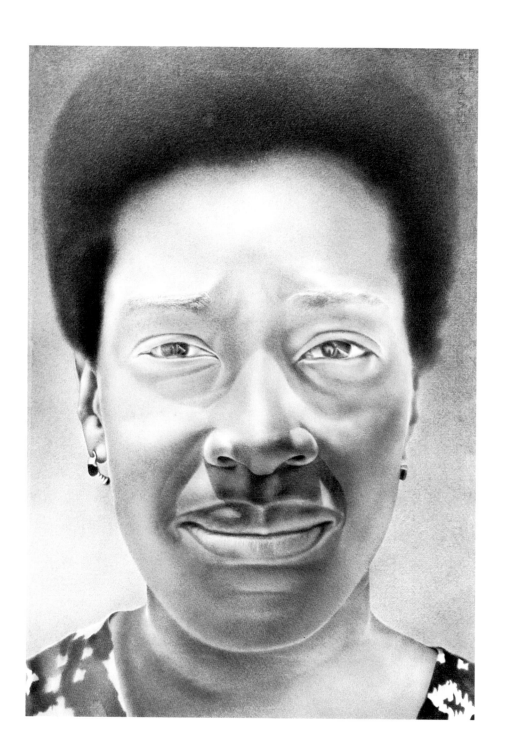

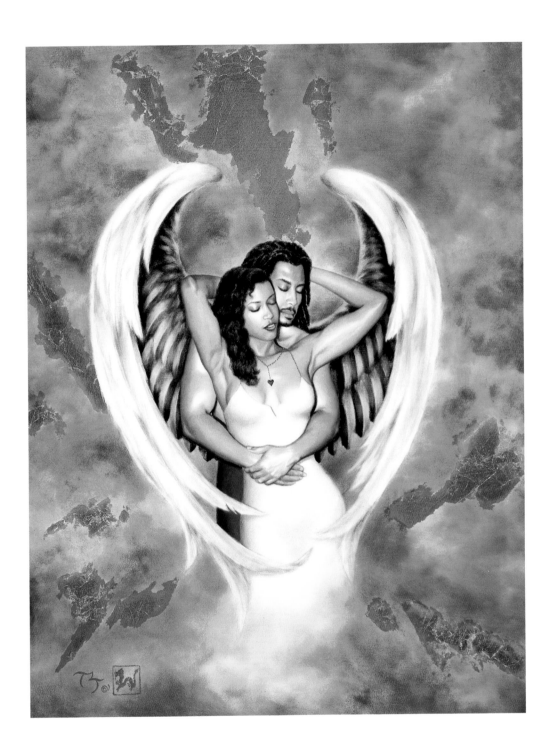

Toni L. Taylor

Born 1958, Mount Vernon, NY
Lives and works in Westchester County, NY

EDUCATION

Self-taught

SELECTED SOLO EXHIBITIONS

2002 Sugar Hill Bistro, New York, NY

SELECTED GROUP EXHIBITIONS

2002 *The Decor Expo*, World Congress Center, Atlanta, GA
2001 *October Gallery International Art Expo*, Philadelphia, PA
 A Holiday Celebration, Simone's Gallery, Pelham, NY

Wrapped in the Arms of Heaven, 2001

Hulbert Waldroup

Born 1966, Chicago, IL
Lives and works in New York, NY

EDUCATION
Self-taught

SELECTED SOLO EXHIBITIONS
2001 *The Manhattan Project*, Gallery M, New York, NY
1998 Corosh Gallery, Chicago, IL

SELECTED GROUP EXHIBITIONS
2001 ABC No Rio Gallery, New York, NY
Art Gallery 113, New York, NY
Group Show with James de la Vega, New York, NY
Lowe Gallery, New York, NY
Stendahl Gallery, New York, NY

Black Man Rising, 2000

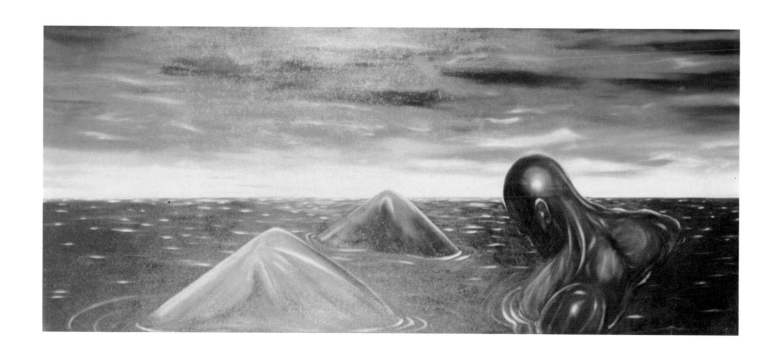

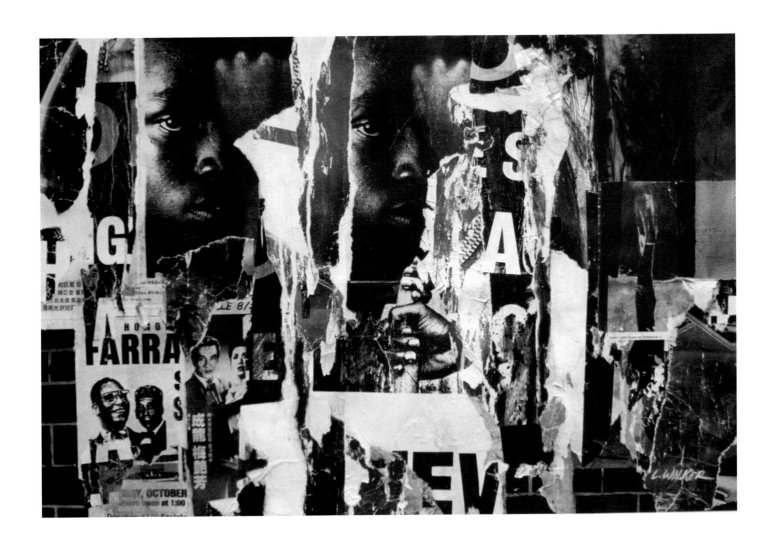

Larry Walker

Born 1935, Franklin, GA
Lives and works in Stone Mountain, GA

EDUCATION

1963 MA Wayne State University, Detroit, MI

1958 BS Wayne State University, Detroit, MI

SELECTED SOLO EXHIBITIONS

2001 *Larry Walker: Four Decades*, City Gallery East, Bureau of
Cultural Affairs, City of Atlanta and Georgia State University
School of Art and Design, Atlanta, GA

1999 *Larry Walker: Saguaro Spirits*, Nexus Contemporary Art
Center, Atlanta, GA

SELECTED GROUP EXHIBITIONS

2002 *LaGrange National XXII Exhibition*, Chattahoochee Valley
Art Museum, LaGrange, GA

2001 *Marking Time: Contemporary Drawings by Georgia Artists*,
Simmons Visual Arts Center, Brenau University Galleries,
Gainesville, GA

2000 *Go Figure*, LewAllen Contemporary, Santa Fe, NM

The Red Clay Survey, Huntsville Museum of Art,
Huntsville, AL

Elegized Wall, 1994

Shamek Weddle

Born 1975, Grand Rapids, MI
Lives and works in Deerfield, MA

EDUCATION

2001 MFA University of Massachusetts, Amherst, MA

1998 MEd University of Massachusetts, Amherst, MA

1997 BFA Virginia State University, Petersburg, VA

SELECTED SOLO EXHIBITIONS

2001 *Holy S****t*, Herter Art Gallery, University of Massachusetts, Amherst, MA

1996 *My Homework Assignment PLUS*, Meredith Gallery Virginia State University, Petersburg, VA

 My Homework Assignment, Tuna Gallery, William Patterson University, Wayne, NJ

SELECTED GROUP EXHIBITIONS

2000 *Painters and Printmakers*, South Gallery, Greenfield Community College, Greenfield, MA

 Student Fine Art Exchange Exhibit, Mitsukoshi, Ninth Floor Gallery, Sapporo, Japan

 Drawing Marathon, Hampden Gallery, University of Massachusetts, Amherst, MA

 Black History Month Art Exhibition, Meredith Gallery, Virginia State University, Petersburg, VA

1999 *Landscape Space*, Clark Hall, University of Massachusetts, Amherst, MA

Self-portrait (blue), 2000

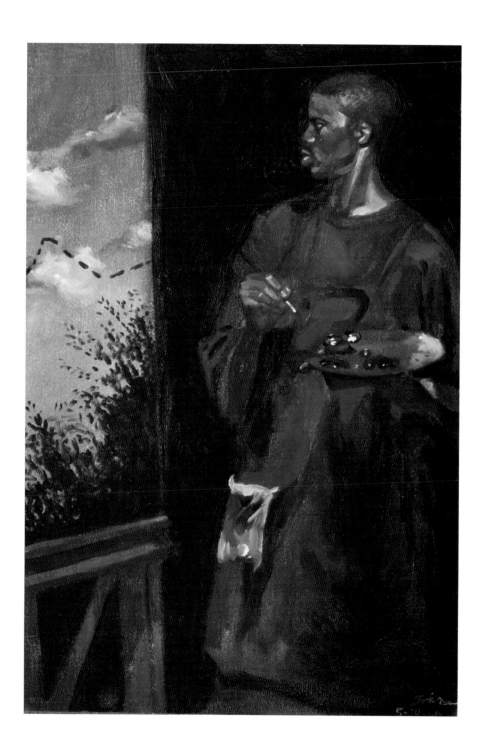

114

Kehinde Wiley

Born 1977, Los Angeles, CA
Lives and works in New York, NY

EDUCATION

2001 MFA Yale University School of Art, New Haven, CT

1999 BFA San Francisco Art Institute, San Francisco, CA

SELECTED SOLO EXHIBITIONS

1995 Image Gallery, Los Angeles, CA

1994 Plus Gallery, Los Angeles, CA

SELECTED GROUP EXHIBITIONS

2001 Rush Arts Gallery, New York, NY

2000 Yale University Art Gallery, New Haven, CT

1999 Diego Rivera Gallery, San Francisco, CA

Open Arts Circle, Oakland, CA

1998 Hackett Freedman Gallery, San Francisco, CA

Conspicious Fraud Series #1
(Eminence), 2001

Contributors

LeRonn Brooks is a writer and a graduate student in Art History at the CUNY Graduate Center in New York.

Valerie Cassel earned an MA in Art History from Howard University (1992), taught at the university level, held positions with the National Endowment for the Arts (1988-1995), and directed the Visiting Arts Programs at The School of the Art Institute of Chicago (1996-2000). In addition, she has served a curatorial team member for The Whitney Museum of American Art 2000 *Biennial*. Currently, she is Associate Curator with the Contemporary Art Museum in Houston, Texas.

Malik Gaines is a writer living in Los Angeles. Gaines contributes art criticism to several publications, including *Artext, Contemporary*, and *Tema Celeste*. Gaines's performance work has included numerous theater productions and continuous efforts with his band, My Barbarian. Gaines currently teaches writing at California State University Fullerton.

Thelma Golden is Deputy Director for Exhibitions and Public Programs at The Studio Museum in Harlem.

Christine Y. Kim is Assistant Curator at The Studio Museum in Harlem. Recent exhibitions include *Africaine: Candice Breitz, Wangechi Mutu, Tracey Rose and Fatimah Tuggar*, and *For the Record: Julie Mehretu, Senam Okudzeto and Nadine Robinson*. Prior to her arrival at The Studio Museum in 2000, Kim was an independent curator and held positions at the Whitney Museum of American Art and Gagosian Gallery.

Kelefa Sanneh writes about popular music for the *New York Times*. He is also deputy editor of *Transition*, an international review of race and culture.

Lowery Stokes Sims is a curator, scholar, consultant, and arts administrator who has directed The Studio Museum in Harlem since January 2000. She served as a curator in the Modern Art (formerly 20th Century Art) Department at The Metropolitan Museum of Art from 1975-1999. She has curated exhibitions on artists as diverse as Stuart Davis, Richard Pousette-Dart, Wifredo Lam, and Magdalena Abakanowicz, and has written extensively on African, Native, Asian, and Latin American artists. In 1991 Ms. Sims was the recipient of the Frank Jewett Mather Award for distinction in art criticism from the College Art Association. Her book *Wifredo Lam and the International Avant-Garde, 1923-1982* will be published in 2002.

Franklin Sirmans is a freelance writer and critic whose work has appeared in the *New York Times* and *Newsweek*. A regular contributor to *Time Out*, he is the former U.S. editor of *Flash Art*. He is also co-curator of the traveling exhibition *One Planet Under A Groove: Hip Hop and Contemporary Art*.

Regina L. Woods is a New York-based writer and an editor with *Black Issues Book Review* magazine. Her work has appeared in publications such as *African Arts, Flash Art, International Review of African-American Art, Guggenheim Magazine*, and *Black Issues Book Review*. Her two favorite poems of the moment: "blessing the boats" and "why some people be mad at me sometimes" by Lucille Clifton.

Works in the Exhibition

ALONZO ADAMS

Man Thought, 2002
Oil on canvas, 18 x 24 in.
Collection of Ernesto Butcher,
South Orange, NJ

Sun-soaked, 2001
Oil on canvas, 30 x 60 in.
Collection of William and Gail
Robinson, Randolph, NJ

LEROY ALLEN

Sundrops, 2001
Watercolor on paper, 30 x 20 in.
Collection of the artist

The Glance, 2001
Charcoal on paper, 12 x 16 in.
Courtesy of Hearne Fine Art,
Little Rock, AK

Papa Jim, 1999
Charcoal on paper, 42 x 26 in.
Collection of the artist

Contemplation, 1998
Watercolor on paper, 21 x 16 in.
Collection of the artist

IANA L.N. AMAUBA

Fly in Milk I, 2001
Oil on linen, 40 x 64 in. (diptych)
Collection of the artist

Fly in Milk II, 2001
Oil on linen, 40 x 64 in. (diptych)
Collection of the artist

JULES R. ARTHUR, III

Black Gold, 2001
Charcoal on paper, 12 x 30 in.
Collection of the artist

Chain Gang, 2000
Charcoal on paper, 30 x 22 in.
Collection of the artist

ALEXANDER AUSTIN

The Compromise, 1995
Graphite on board, 40 x 30 in.
Collection of the artist

Spirit of the Dream, 1994
Graphite on board, 28 x 39 in.
Collection of the artist

MARLON H. BANKS

Blue-Black and Present, 2000
Watercolor on paper, 29 x 21 3/4 in.
Collection of the artist

William Undressing Stereotypes, 1999
Watercolor, charcoal and graphite on
paper, 52 x 32 1/2 in.
Collection of the artist

Invisible Man, 1997
Watercolor on paper, 22 1/2 in. x 47 in.
Collection of the artist

NINA I. BUXENBAUM

The Annunciation, 2000
Oil on canvas, 41 x 66 in.
Collection of the artist

The Palette-able Artist, 2000
Oil on canvas, 48 x 48 in.
Collection of the artist

CLIFFORD DARRETT

Line Dance, 2002
Oil on Canvas, 36 x 48 in.
Collection of the artist

Bless This Family, 2000
Oil on canvas, 30 x 24 in.
Collection of the artist

The Drum Lesson, 1999
Oil on canvas, 24 x 20 in.
Collection of the artist

At the Festival, 2000
Oil on canvas, 40 x 30 in.
Collection of the artist

KEITH J. DUNCAN

An Angel Amongst Us, 2001
Photo collage, oil, and marker on
canvas, 18 x 24 in.
Collection of the artist

Cain and Abel, 2001
Photo collage, oil, and marker on
canvas, 16 x 12 in.
Collection of the artist

The Conversion of Saul II, 2001
Collage, oil, photo and marker on
canvas, 16 x 12 in.
Collection of the artist

LAWRENCE FINNEY

I Have Seen So Much, 2002
Oil on linen, 16 x 12 in.
Collection of Reginald J. Lewis,
New York, NY

City Boy, Red Scarf, 2001
Oil on canvas, 14 x 11 in.
Collection of the artist

Blond Bouffant, 2001
Oil on canvas, 14 x 11 in.
Collection of the artist

City Girl, Magenta Wig, 2001
Oil on canvas, 14 x 11 in.
Collection of the artist

*City Girl, Burgundy and
Orange Hair*, 2001
Oil on canvas, 14 x 11 in.
Collection of Danny Simmons,
Brooklyn, NY

GERALD GRIFFIN

Foundation, 1997
Oil on canvas, 24 x 24 in.
Collection of Mark Watts, Chicago, IL

Human Nature, 2000
Oil on canvas, 30 x 40 in.
Collection of the artist

The Yearning, 2000
Oil on canvas, 36 x 48 in.
Collection of the artist

Black Venus, 1997
Oil on canvas, 40 x 30 in.
Collection of John and Sharon
Matthews, Chicago, IL

JAMES HOSTON

Hot Day In, 1998
Oil on linen, 40 x 30 in.
Collection of Dr. George A. Williams,
Jr., New York, NY

James Howell, 1996
Oil on linen, 40 x 30 in.
Collection of James Howell,
Jersey City, NJ

ROBERT L. JEFFERSON

Risen, 1999
Watercolor on paper, 30 x 24 in.
Collection of the artist

Seek… the Light, 1999
Watercolor on paper, 30 x 24 in.
Collection of the artist

OLIVER B. JOHNSON, JR.

Jumping Rope, 1996
Oil on canvas, 29 1/2 x 27 1/2 in.
Collection of Bruce Gordon and Tawana
Tibbs, New York, NY

Madonna and Child, 1995
Oil on canvas, 30 x 24 in.
Collection of Laura and Richard
Parsons, New York, NY

Little Man, 2002
Oil on masonite, 16 x 12 in.
Courtesy Peg Alston Fine Arts,
New York, NY

TROY L. JOHNSON

Talking with Friend, 2001
Oil on canvas, 18 x 24 in.
Collection of the artist

Block Meeting, 1995
Oil on canvas, 41 1/2 x 48 in.
Collection of Roslyn McClendon,
Detroit, MI

Quilting the Fabrics of Life, 1994
Oil on canvas, 84 x 66 in.
Collection of Evelyn Higginbotham,
Auburndale, MA

JONATHAN M. KNIGHT

Ring Bearer, 1994
Watercolor on board, 24 x 22 in.
Collection of the artist

Innocence, 1993
Watercolor on board, 32 x 28 in.
Collection of Dr. Catherine Lowe,
West Palm Beach, FL

JEANETTE MADDEN

Sunshine on Mariama, 2000
Acrylic on canvas paper, 16 x 12 in.
Collection of the artist

Woman with Flowers, 1987
Pastel on paper, 20 x 15 in.
Collection of the artist

CAL MASSEY

The Messiah, 1982
Acrylic on canvas, 30 x 48 in.
Collection of the artist

Angel Heart/The Ascension, 1987
Acrylic and color pencil on board
36 x 26 in.
Collection of the artist

DEAN MITCHELL

Laid Back, 2001
Oil on panel, 47 3/4 x 39 7/8 in.
Collection of the artist

Lady in Black, 1999
Watercolor on paper, 4 3/4 x 3 1/2 in.
Collection of the artist

Boundary, 1995
Oil on panel, 40 x 30 in.
Collection of the artist

Sam and Dolly (Silent Strength), 1995
Oil on panel, 30 x 48 1/8 in.
Collection of the artist

Socrates, 2001
Oil on board, 24 x 15 1/2 in.
Collection of Martha Comer,
Corrales, NM

KADIR NELSON

Africa, 2001
Oil on canvas, 16 x 20 in.
Collection of Darrell and Paula
Williams, Los Angeles, CA

Next Five, 2001
Oil on canvas, 22 x 22 in.
Collection of the artist

Beautiful, 1999
Oil on canvas, 22 x 22 in.
Collection of the John McClain,
Beverly Hills, CA

Big Men, 1999
Oil on canvas, 48 x 36 in.
Collection of the artist

Right Wing, 1999
Oil on canvas, 22 x 18 in.
Collection of the artist

The Rucker, 2000
Oil on canvas, 80 x 42 in.
Collection of the artist

LESLIE PRINTIS

Old Fashion Girl in New Times, 2001
Oil on canvas, 23 x 34 1/4 in.
Collection of the artist

Discovery, 2001
Oil on canvas, 20 x 20 in.
Collection of Dr John Patton,
San Carlos, CA

After the Party, 2001
Oil on canvas, 38 x 35 in.
Collection of Carol Cody, Gary, IN

ROBERT V. REID

The Essence of Love, 2000
Charcoal on paper, 35 x 30 in.
Collection of the artist

Hold Tight, 1999
Charcoal on paper, 29 x 20 in.
Collection of the artist

JONATHON ROMAIN

Still Waters, 2001
Oil on canvas, 24 x 30 in.
Collection of Dr. Thelma Wiley,
Chicago, IL

A Mile in My Shoes, 1999
Oil on canvas, 48 x 60 in.
Collection of the artist

Untitled, 2000
Oil on canvas, 30 x 40 in.
Collection of Malika Young,
Atlanta, GA

PHILIP SMALLWOOD

Another Morning I Rise, 1998
Watercolor on paper, 30 x 20 in.
Collection of Carl and Mary Roberts,
Kalamazoo, MI

Desire, 1998
Watercolor on paper, 21 1/2 x 29 in.
Collection of the artist

My Turn, 1999
Watercolor on paper, 29 x 20 5/8 in.
Collection of the artist

Sunshine, 2000
Watercolor paper, 29 x 21 7/8 in.
Collection of Pamela and Kevin Carter,
Oklahoma City, OK

AJ SMITH

Marvin, 2000
Pencil on paper, 46 x 36 in.
Collection of the artist

Marjorie, 1997
Pencil on paper, 46 x 36 in.
Collection of the artist

TONI L. TAYLOR

On My Mind, 2002
Oil on board, 16 x 22 in.
Collection of the artist

On My Mind Too, 2002
Oil on board, 16 x 22 in.
Collection of the artist

Wrapped in the Arms of Heaven, 2001
Oil and gold leaf on board, 18 x 14 in.
Collection of the artist

Gemini—Souls Akin, 2001
Oil on board, 24 x 20 in.
Collection of the artist

HULBERT WALDROUP

Black Man Rising, 2000
Oil on canvas, 36 x 84 in.
Courtesy Gallery M, New York, NY

LARRY WALKER

Elegized Wall, 1994
Collage on paper, 28 x 36 in.
Collection of the artist

Going Home II, 2002
Acrylic on paper, 28 x 36 in.
Collection of the artist

SHAMEK WEDDLE

Water-boy, 2001
Oil on canvas, 24 x 30 in.
Collection of the artist

Self-portrait at age 24, 2000
Oil on canvas paper mounted
on board, 20 x 16 in.
Collection of the artist

Self-portrait (blue), 2000
Oil on paper mounted on board,
20 x 13 in.
Collection of the artist

KEHINDE WILEY

*Conspicuous Fraud Series #1
(Eminence)*, 2001
Oil on canvas, 77 x 77 in.
Collection of the artist

Untitled, 1998
Oil on wood panel, 40 x 36 in.
Collection of the artist

Untitled, 1998
Oil on wood panel, 40 x 36 in.
Collection of the artist

Lowery Stokes Sims
Director

Rosi Ng
Assistant to Director

Deirdre Scott
*Consultant for Technology &
Digital Media*

Jamie Glover
Museum Store Manager

Ramona Cuevas
Museum Store Sales Assistant

Barbara Hall
Museum Store Sales Assistant

Ann Jackson
Volunteer, Museum Store

Thelma Golden
*Deputy Director for
Exhibition & Programs*

Christine Y. Kim
Assistant Curator

Rashida Bumbray
Curatorial Assistant

Anne Kovach
Registrar

Roy Williams
Head Preparator

Ali Evans
Michelle Wilkinson
Curatorial Interns

Sandra Jackson
*Director of Education &
Public Programs*

Jonell Jaime
*Head of School &
Family Programs*

Carol Martin
*Education & Public
Programs Assistant*

Rayne M. Roberts
Coordinator, Expanding the Walls

Lauren Rhodes
Melissa Alvarez
Education Interns

Kira Lynn Harris
Adia Millett
Kehinde Wiley
Artists-in-Residence

Susan Wright
*Development Associate
for Special Events*

Vivienne Valentine
*Development Assistant
for Grants*

Antonio Easterling
*Development Assistant
for Membership*

Pam Kaskel
*Development Assistant
for Database Management*

Joyce Parr
Comptroller

Helen Holt-Vasquez
*Assistant to Comptroller,
Accounts Payable*

Wendy Davidson
*Assistant to Comptroller,
Accounts Receivable & Payroll*

Winston Kelly
Deputy Director for Operations

Terry Parker
Security Supervisor

Norris Robinson
Security Supervisor

Linda Thomas
Fire Safety Director

James Fitzroy
Devis Jackson
Paul James
Joy Mitchell
Mark Ramsden
Teddy Webb
Security Officers

Simon Golson
Maintenance Supervisor

Angad Brijnanan
Santos Tirado
Custodians

This exhibition was organized at
The Studio Museum in Harlem by Thelma Golden.
This publication was organized by Christine Y. Kim,
Assistant Curator, with the assistance of Rashida
Bumbray, Curatorial Assistant, and Ali Evans,
Curatorial Intern.

Edited by Michelle Wilkinson
Interviews transcribed by Damion Lawyer
Design by Brian Hodge
Printing by Snoeck-Ducaju & Zoon
Printed and bound in Belgium

124

Front Cover: Kadir Nelson, **Africa** (detail), 2001; back cover:
Keith Duncan, **An Angel Amongst Us** (detail), 2001; front
flap: Kehinde Wiley, **Conspicuous Fraud Series #2 (The
Committee)** (detail), 2001; back flap: Dean Mitchell,
Socrates, 2001; p. 1: Lawrence Finney, **I Have Seen So
Much,** 2002; p. 2: Marlon H. Banks, **Invisible Man,** 1997;
p. 3: Cal Massey, **Angel Heart/The Ascension,** 1987; p. 4:
Nina I. Buxenbaum, **The Palette-able Artist,** 2000; p. 125:
Robert L. Jefferson, **Risen,** 1999; p. 126: Leslie Printis,
Discovery, 2001; p. 127: Aj Smith, **Marvin,** 2000; p. 128:
Shamek Weddle, **Water-boy,** 2001.

Robert L. Jefferson

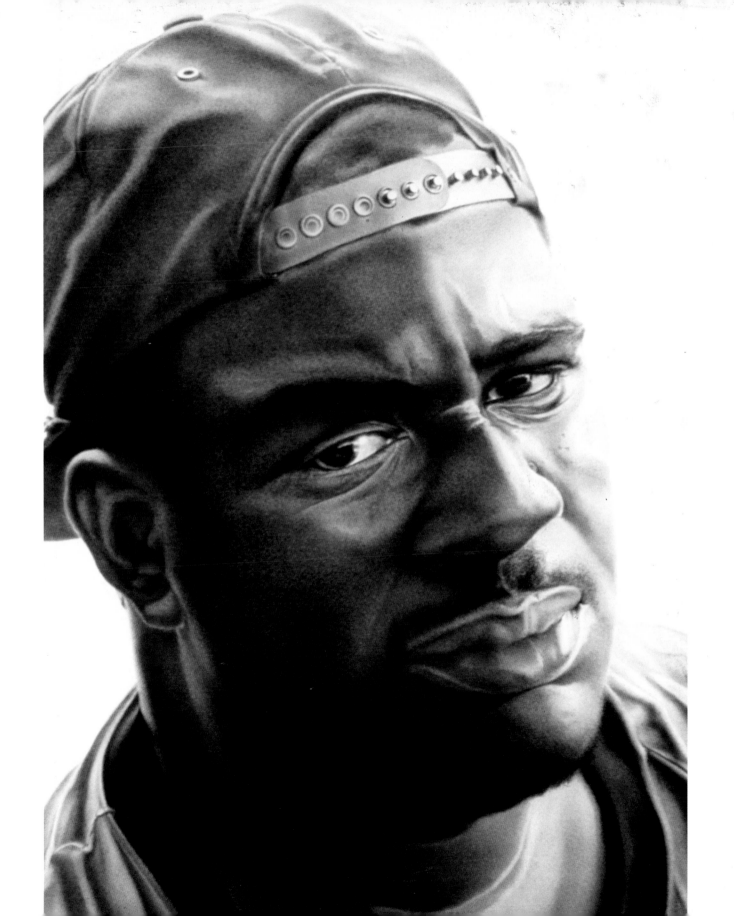